MASTERING

FILTERS FOR PHOTOGRAPHY

Published in the United States by Amphoto
Books, an imprint of the Crown Publishing
Group, a division of Random House, Inc.,
New York.
www.crownpublishing.com
www.amphotobooks.com

AMPHOTO BOOKS and the Amphoto Books
logo are trademarks of Random House, Inc.

Library of Congress Control Number:
2009926712

ISBN: 978-0-8174-2451-0

10 9 8 7 6 5 4 3 2 1

First Amphoto Books Edition

Originally published in Great Britain as
*Mastering Filters for Photography: Professional
Digital and Optical Techniques* by RotoVision
SA, Hove.

Copyright © RotoVision SA 2009

Art Director Tony Seddon
Design by Studio Ink

Reprographics in Singapore by ProVision Pte.
Tel: +65 6334 7720
Fax: +65 6334 7721

Printing and binding in China by 1010 Printing
International Ltd.

MASTERING

FILTERS FOR
PHOTOGRAPHY

THE COMPLETE GUIDE TO DIGITAL AND OPTICAL
TECHNIQUES FOR HIGH-IMPACT PHOTOS

CHRIS WESTON

AMPHOTO BOOKS

an imprint of The Crown Publishing Group
New York

CONTENTS

6618

The photographic world is constantly changing, and with every change grows the demand for more up-to-date, relevant information. We live and photograph in a largely digital age that has provided us with many opportunities to achieve technical perfection and greater creativity, but in order to enjoy the benefits of this new technology we must learn when and how to apply it. This is what this book is all about.

In terms of filters we have, to an extent, come full circle. When Cokin introduced its innovative, low-cost slot-in filter system in the early 1980s, photographers went wild with all sorts of strange new filter effects. Photography magazines were awash with images of starbursts, diffracted light, sepia skies, and mock rainbows as a whole new world of creativity was opened up to the enthusiast masses. Over time this initial enthusiasm calmed, and optical filters were used more for their technical and subtly creative properties, rather than for crafting unnatural creations. I suspect that many of those early images never made it into photographers' personal archives—I know mine never did!

Then along came image-processing software, and creative mayhem was once again sparked. Amid this flurry of creativity there is a serious side to photographic filters in the digital age, and it is this side of the filter equation that this book addresses.

One of the questions I am often asked is whether optical filters still have a place in our kitbags. After examining the use of filters throughout this book it becomes very obvious that they do. As with anything equipment-related, it is a question of choosing the right tool for the job at hand, and what I have set out to achieve throughout the text and illustrations is a guide to making the correct decisions.

It is also important not to forget that film cameras still exist and are in plentiful use today despite the lurch toward digital. I am a good example of this. Even though I rely on my digital SLR (DSLR) when photographing wildlife, I still prefer to revert to a film-based large-format camera when shooting landscape scenes. Here the question arises whether digital technology has a place when shooting with film.

Throughout the following pages, *Mastering Filters for Photography* examines and answers questions such as this, plus many more. From the often-overlooked subject of choosing between filter systems—something that can lead to many inappropriate choices and considerable wasted expense—to the effects filters have when used with a digital camera, and deciding when to use optical filters over computer-based processing.

The bulk of the book is given over to explaining what different filters do and how to use them effectively. Information about highly technical filters, such as polarizers and graduated neutral density filters, is explained using simple step-by-step instructions. The subtle benefits of color correction and conversion filters are also examined, including a brilliantly simple technique for using the White Balance (WB) control on a digital camera to replicate 81 series warming and 80 series cooling filters (see page 148). Information on creative filters, such as colored graduated and soft-focus filters, is included, as well as details about custom filters used by the pros.

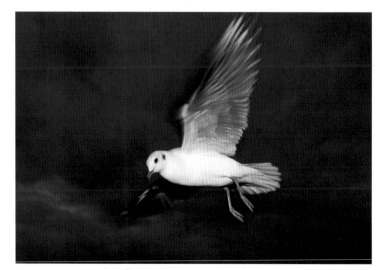

LEFT
Filters can be used to creatively enhance or add color to your photographs.

RIGHT
This book provides useful advice on how to choose the best technical filter for the job at hand, such as shooting outdoors in difficult weather conditions.

There is also a section dedicated to the subject of black-and-white photography, a genre that has seen a revival in recent years, and one where filtration, either optical or digital, has a large part to play. Similarly, the book reveals easy-to-implement methods of replicating older camera and darkroom techniques, such as infrared.

Having examined the arguments for and against applying filters digitally, a large section is also devoted to examining some of the most useful and relevant digital filter techniques from the leading software manufacturers.

To help with making this book easy to understand and the techniques discussed simple to apply, I have used many comparative images, showing before and after scenes, as well as easy-to-follow step-by-step instructions.

They say a picture speaks a thousand words, and the use of comparative images helps greatly in visualizing the effects of different filters. Similarly, when discussing digital filter techniques I have used screenshots to make the instructions easy to follow.

In our modern, fast-paced world we need information presented in a particular way in order to gain the most benefit from it. We receive and process information differently than we used to, and any how-to book such as this needs to meet the challenges of teaching to a modern audience. Do we need another book about filters? If we really want to help photographers create better images then the answer is, yes, we do. And this is that book.

ABOVE
Polarizing filters have deepened the color of the blue sky in this image. See pages 86–93.

BELOW
Even the worst of conditions can result in evocative images.

Photo Filter

Use

◉ Filter: Warming Filter (85)

○ Color:

OK
Cancel
☑ Preview

Density: 25 %

☑ Preserve Luminosity

LEFT
Applied with care, digital filter techniques have become extremely important tools for photographers.

ABOVE
As well as examining the technical application of filters, this book also explores how filters can be used to achieve creative effects, such as this warm mountain scene.

Section 1

Filter Systems

A

One of the many questions that the medium of digital photography poses is if there is still a need for optical filters, or whether the effects created by such filters—long associated with film photography—can just as easily be replicated during computer-based post-capture image processing. There is no black-and-white answer. I have peers who swear by their optical filter systems and argue that a computer is incapable of matching the quality of the "real thing." On the other hand, just as many peers argue that computer processing is not only a comparable solution, but also a far more practical and efficient one. Without wishing to sit on the fence, I can find merit in both sides of the argument.

The truth is, as with most things photographic, it is a question of using the right tool for the job at hand. There are circumstances when using optical filters are appropriate, and others when the need for filtration can successfully be dealt with via digital means. This

section deals with deciding between the two options so that, when the time comes, you are able to make an informed choice that will help toward maximizing image quality.

The main purpose of filters is to change the characteristics of light entering the camera. The question, then, is whether these characteristics can be altered by a computer to the same degree and without compromising the overall quality of the resulting image. To illustrate, let's consider two different scenarios:

Scenario one: a landscape scene is photographed on a late summer morning when there is a greater proportion of blue light waves (due to the higher color temperature of light at this time of day—see page 68), which gives the overall scene a cool color cast.

Scenario two: a landscape scene that consists of a very brightly lit sky and a foreground in deep shadow, where

scene dynamic range (SDR; the difference in brightness between the darkest and lightest parts of the scene) exceeds the dynamic range (DR) of the camera (i.e. the camera's ability to record detail in areas of highlight and shadow simultaneously).

In the first scenario you might use an 81 series amber warming filter (see page 70) in order to block a high proportion of the blue light waves present, allowing the red light waves to predominate. This cancels out the blue (cool) color cast, thereby creating a warmer effect.

ABOVE AND RIGHT
Filters are designed to change the characteristics of light. Here an 81A (image A) and an 81C (image B) filter have been used to filter out the high level of blue light waves. Notice how the stronger 81C filter has created a deeper orange (warm) color cast (image C).

B

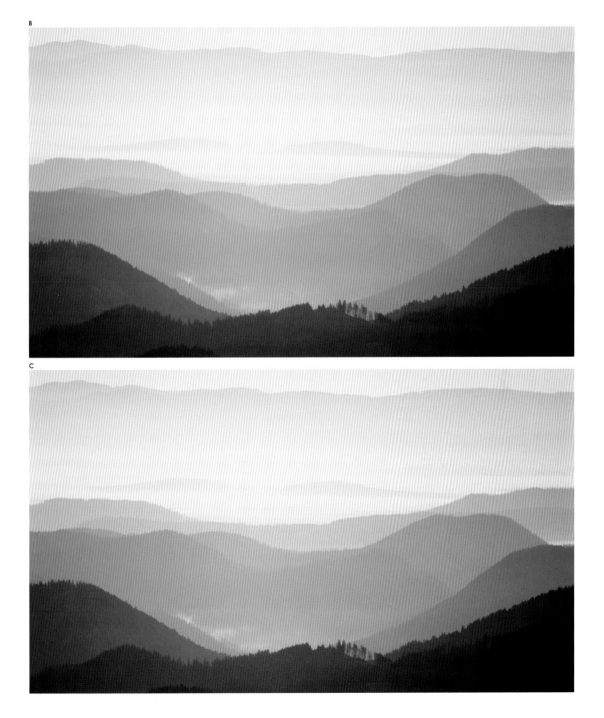

C

A

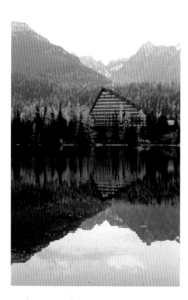

B

LEFT AND RIGHT
In these shots, the SDR exceeded the camera's ability to record DR, resulting in a sky with burned out highlights (image A). Exposing for the bright sky fixed this problem, but created another— underexposing the shadow areas in image B. By using a GND filter I have been able to reduce SDR to a level within the camera's DR, resulting in a perfectly exposed image (image C).

In the second scenario, the ideal solution is to use a graduated neutral density (GND) filter of the correct strength (see page 50) to block light from the brightest part of the scene, effectively reducing SDR to a level within the camera's ability to record it.

What these scenarios illustrate are two very different photographic problems. In scenario one, the problem caused by the lighting condition is one of color. It's not a question that the level of light cannot be recorded, but simply that its color may be less aesthetically pleasing. In this instance, it would be just as easy and effective to alter the color cast during the image-processing stage as it would be at the point of capture. And, one might argue, to use computer processing would overcome the perceived problem of having to carry around a stack of filters.

In scenario two, however, the problem raised is one where the camera is incapable of recording the full range of brightness levels present in the scene. If SDR isn't dealt with at the point of capture, then the resulting digital file will contain either areas of burned-out highlights or grossly underexposed areas of shadow (or possibly both). In this case, no amount of computer processing will be able to recover the situation without significantly and adversely affecting image quality, or without a lengthy amount of time being spent in front of the computer cloning and pasting in detail where pixel information has been lost. In this instance, the most effective and efficient solution is to fix the problem at the source—at the point of capture—using an optical filter.

This example illustrates that the most ideal filter solution can be decided after considering the effects of taking the photograph without using an optical filter at all. If the effects of the filter can easily be recreated during image processing without compromising image quality, then the only remaining question is whether the aim is to produce a print-ready image file direct from the camera, or whether a small amount of post-capture processing is acceptable. Where the latter is the case, a digital filter solution is appropriate. However, in the case of the former, an optical solution would be better.

In instances when using no filter will compromise the quality of the data recorded by the camera, the best solution by far is to use an appropriate optical filter. Not only will this improve the quality of the resulting print or digital file, it will also save a great deal of time and effort.

C

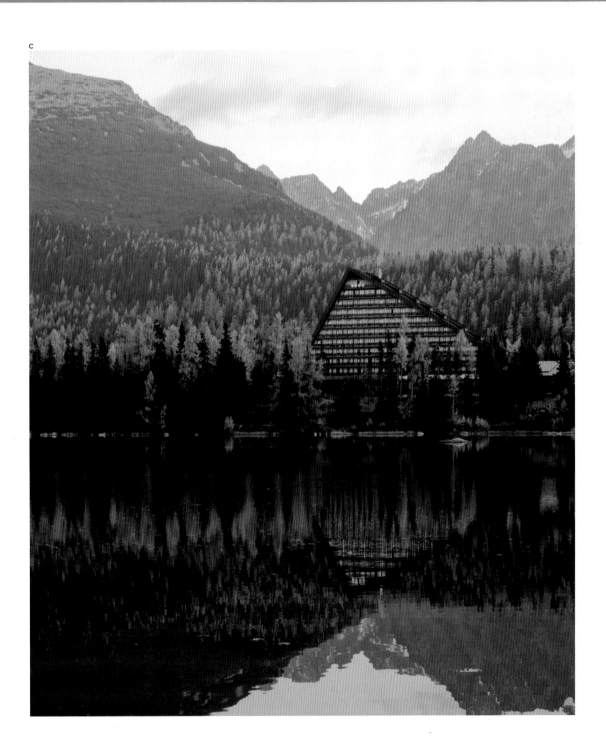

Optical filters are used at the point of capture by being placed in front of the lens or, in the case of some fast (typically telephoto) lenses, slotted into the lens barrel between the rear lens elements and the camera. They come in a variety of sizes and are traditionally made of glass, resin, or polyester gel. They may be of the screw-in variety or form part of a system. To help you choose between filter types and manufacturers I will cover each of these points in detail over the following pages.

ABOVE
Polarizing filters are designed to filter out non-polarized light in order to remove reflections in non-metallic shiny surfaces.

RIGHT
Before and after: a creative starburst filter has been used to add a starlike twinkle to the highlights on the wedding ring in image B.

Filter types and their uses

Filters typically fall into one of two categories, being either technical or creative in nature. In simple terms, technical filters are designed to overcome the limitations of cameras when recording light. Polarizing filters are a type of technical filter that filter out non-polarized light in order to remove reflections in non-metallic shiny surfaces such as glass. Other technical filters include neutral density (ND) and graduated neutral density (GND) filters, which are used to block light; color correction filters, which are used to compensate for color casts; and UV filters, used to lessen the effects of ultraviolet light that are invisible to the human eye but are recorded by film and digital sensors. On the other hand, creative filters are used to achieve artistic effects, and include starburst filters, which create a starlike effect on points of bright light; diffraction filters, which break up light into its constituent parts to give a prismlike effect to highlights; colored graduated filters, which may be used to alter the color of a sky; and softening filters, often used in portrait and wedding photography.

It is impractical to mention all of the different filter varieties available here as there are hundreds on the market. Instead, the tables opposite provide a list of commonly used filters and their effects.

A
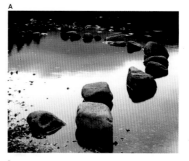

B

ABOVE
Polarizing filters eliminate reflections from non-metallic shiny surfaces, such as glass and water, as well as saturating colors. Notice how the water is a much deeper blue at full polarization in image A than it is in image B.

A
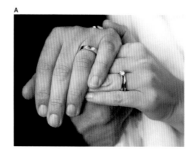

B

LEFT
Softening filters minimize the effects of wrinkles, spots, and skin blemishes.

ABOVE
Softening filters are often used in portrait and wedding photography as they soften image detail.

TECHNICAL FILTERS

Filter Type	Effect
Polarizer	Saturates colors; minimizes reflections from non-metallic shiny surfaces
Ultraviolet	Blocks UV light, protects the front lens element
Neutral density (ND)	Blocks a specified quantity of light across the whole image space
Graduated neutral density (GND)	Blocks a specified quantity of light in a partial area of the image space
Color temperature (CT)	Removes or adds red/orange or blue color casts
Color conversion	Removes or adds red/orange or blue color casts
Color compensating	Removes or adds color casts
Colored filters (black and white)	Manages contrast in black-and-white photography

CREATIVE FILTERS

Filter Type	Effect
Colored	Adds color cast
Graduated colored	Adds color cast to a partial area of the image space
Soft-focus	Softens image detail
Starburst	Adds starlike effects to bright highlights
Diffraction	Adds colored halos around bright highlights
Infrared	Blocks visible light, for use with infrared film (and adapted digital sensors)
Close-up	Increases reproduction ratios for close-up photography

The quality of any optical filter is paramount. After all, there is little point spending lots of money on a high-performance lens if you then add a poor-quality, cheap filter to it. This will degrade the quality of light transmitted through it by introducing aberrations, or by reflecting a large percentage of the light away from the lens, therefore reducing contrast.

RIGHT
Glass filters can alter light to enhance colors and contrast and create specific moods.

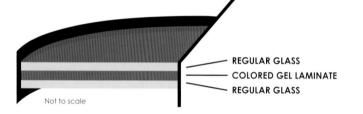

— REGULAR GLASS
— COLORED GEL LAMINATE
— REGULAR GLASS

Not to scale

Not to scale **UNIFORMLY COLORED GLASS**

TOP
Laminate filters are cheap to produce but over time become prone to delamination, rendering the filter useless.

ABOVE
Uniformly colored filters are longer lasting than laminate filters.

Glass

Optical glass filters arguably achieve images of the best quality. Glass is more durable than alternative substances and more resistant to scratching. However, it's worth noting that, as with lenses, there is an element of getting what you pay for. Not all glass is of equal quality and some manufacturer's filters give a better performance than others, just as some lenses produce better-quality images than others. For example, in terms of colored glass filters, there are different manufacturing processes that will impact the optical quality of the filter.

Some less expensive filters are often made using a thin gel or glue laminate sandwiched between two pieces of non-optical regular clear glass. They are cheap to produce but prone to delamination (where the different materials separate), rendering the filter useless. Also, the colored gels are liable to fade and are fallible to color shifts; misalignment of the different surfaces can also lead to focus shifts.

I'm unaware of any formal comparative tests, so any preference for one manufacturer over another is largely subjective. For the record, from my own experience in the field when using glass screw-in filters, I choose to use those made by B+W and Hoya, and when using resin slot-in filters I opt for those manufactured by Lee Filters.

Multicoating

Just as modern lenses are coated for better performance, so too are some glass filters. Coated and multicoated filters help to prevent reflections from between 50 percent (single-coated) and 90 percent (multicoated), enabling 98–99 percent of the light striking the filter to pass through it. As well as reducing reflections and aberrations, this improves contrast for better reproduction. Digital cameras are particularly susceptible to stray light and reflections. When shooting digitally, it is recommended that only multicoated filters be used.

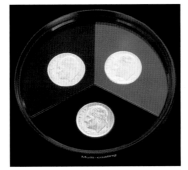

LEFT
Multicoating greatly improves the performance of filters.

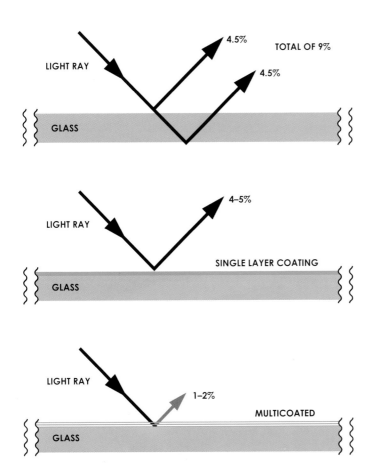

LEFT
Uncoated glass filters reflect a high proportion of light hitting the surface, which reduces image quality.

LEFT
Single-coated filters reduce the amount of light reflected by the filter's surface by up to 50 percent, an improvement on uncoated filters.

LEFT
Multicoated filters reduce the amount of light reflected by the filter's surface by up to 90 percent, which results in a higher-quality transmission of light and better image quality.

Resin

Many of the filters used in slot-in systems, such as those made by Cokin and Lee, are manufactured from an optical resin known as CR-39. These filters are almost unbreakable, making them less fragile than glass filters, but are more prone to becoming scratched, particularly with repeated cleaning. As with glass filters, quality varies between manufacturers; the more expensive products typically offer better optical quality and longer life.

LEFT
Resin filters are almost unbreakable, but are prone to becoming scratched.

LEFT
Proper care and storage will increase the life of resin filters.

BIREFRINGENCE

Some observers using polyester filters have noted particular problems with a phenomenon known as birefringence, where the two polarizations of light have different refractive indices, leading to banding and erroneous color patterns. While this problem has been seen to arise under various conditions, in particular one should avoid using polyester filters in front of a polarizing filter.

Lens cleaning cloth

LEE Filters

Polyester gel

Polyester gel filters, which should not be confused with colored gels that are used with photographic lighting, are made of a very thin material held in place by a rigid frame. They are inexpensive and offer a less costly solution when a large number of filters of a specific type, such as color correction filters, are needed. Polyester filters have a good optical quality due to being so thin; however, relative to other types of material used in filter manufacture, polyester filters are flimsy and prone to becoming scratched and splitting, making them inappropriate for heavy-duty use.

LEFT
Polyester gel filters are made of a very thin material held in place by a rigid frame.

ABOVE
Polyester filters are typically used in conjunction with a special holder.

LONG FOCAL LENGTH LENSES AND FILTERS

One argument for using a polyester filter relates to long focal length lenses. Physically thick filters, such as those made of resin or multicoated glass, may increase the possibility of focal shifts in longer focal length lenses. Under such circumstances, thinner polyester filters are advantageous, as they are less likely to cause the same problem.

Filters are available in either the screw-in or drop-in variety, or they form part of a slot-in system. Screw-in filters attach to the front of a lens via a screw thread. They are made in several sizes to fit lenses with different front element measurements, such as 52mm, 58mm, 67mm, etc. Slot-in filters are similar in design, but are dropped into the lens via a special holder at the rear of the lens barrel. Slot-in filters are typically used with very fast, long focal length lenses that have large front elements.

Screw-in filters
The advantage of screw-in filters is that they are convenient, particularly if you often use one filter type. For example, many photographers permanently attach a UV filter to the front of a lens, as much for protection as the technical properties it provides. In this instance, it is far more convenient to simply screw a filter in and leave it there. From my own experiences photographing wildlife using film, I nearly always have an 81A warming filter attached to my lenses. Again, in this instance, using the screw-in variety is far more convenient than having a slot-in system attached to the lens at all times.

The downside to these filters is their inflexibility. If you own several lenses with front elements of varying diameters then you need several versions of the same filter to fit those lenses. For example, I own lenses that measure 52mm, 58mm, 62mm, 72mm, and 77mm in diameter. This means I would need five versions of each filter type to cover all of my lenses. Furthermore, once in place, the position of the filter is fixed. This matters a great deal when using split or graduated filters because the position of the graduation line is fixed and immovable, restricting compositional opportunities.

Slot-in filters
The alternative to screw-in filters is to use a slot-in filter system. These systems comprise a rigid filter holder that attaches to the front of the lens via an adaptor ring. These rings are available in different sizes, from around 39mm up to 105mm. Depending on the system used, they match practically all variances in lens filter thread sizes. The holder is a fixed size and filters are made to fit the holder, slotting in along a guide mount. Typically, the holders have multiple slots, enabling more than one filter to be used simultaneously.

Slot-in filter systems are versatile and flexible, and offer a number of advantages. One obvious advantage is that you need only one filter of any type, as the adaptor rings enable the holder to be attached to lenses of varying sizes. This saves on both space and cost. Secondly, the system better suits split/graduated filters, as the graduation line can be positioned anywhere along the filter holder guide to suit the required composition.

Additionally, the holder can be rotated to any angle, making it easier to balance exposures where the horizon line is punctuated. Similarly, by attaching multiple holders it is possible to position multiple split/graduated filters to more closely match the shape of a non-uniform subject.

On the negative side, slot-in filter systems are quite bulky, particularly compared to the screw-in variety. They are also more expensive if you have only one or two lenses of different diameters. More importantly, they prevent the use of proprietary lens hoods that have been designed to work with specific lenses and, although most slot-in filter systems have specially made lens hoods available, including ones designed for use with wide-angle lenses, vignetting may occur.

Once again, there is rarely an occasion when one size fits all. Invariably, I have found that mixing systems is inevitable. For example, I use screw-in UV filters, yet opt for the slot-in system for most other filters, including polarizers and graduated filters. As with most equipment-related choices, it comes down to choosing the right tools for the job.

ABOVE
A slot-in filter system.

ABOVE
Adaptor rings are available in different sizes, enabling a slot-in filter holder to be attached to practically any size lens.

ABOVE
Slot-in filters are dropped into a filter holder for precise positioning.

BELOW
The filter holder can be rotated to any angle, making filters such as graduated/split filters more effective.

BELOW
Cokin's X-Pro series filter system is mainly designed for videographers and broadcasters, but can be used with medium- and large-format cameras, particularly when extreme wide-angle lenses are used.

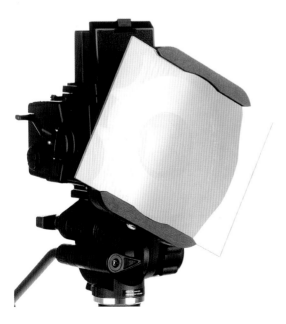

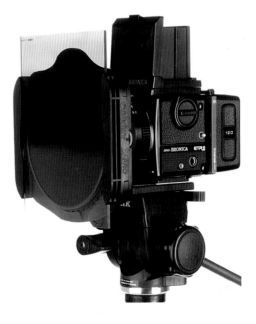

Specialist systems

Using filters with rangefinder cameras can create some unique challenges. The most obvious is that, unlike SLR or DSLR cameras, it is impossible to see the effects of the filter through the viewfinder. This can be particularly problematic when using filters such as polarizers, where the degree of rotation significantly alters their effect. Similarly, accurate positioning of graduated/split filters can be problematic. The physical size and structure of slot-in filters are also inconvenient for use with rangefinders; the holder blocking the view through the viewfinder and often restricting the taking of in-camera light meter readings.

Because of these challenges, the only practical option when using rangefinder cameras has been to use screw-in filters, which limits how the filters can be used in much the same way that they are disadvantageous to SLR and DSLR users. One solution is to use a method of tacking slot-in filters to the front of the lens. Although surprisingly effective, this method has some disadvantages, not least of which is the propensity for the filter to dislodge and fall to the ground, getting scratched and cracked along the way. To solve this problem, Lee Filters has developed a slot-in system specifically designed for use with rangefinder cameras.

Although the system holder can be fitted to any lens on any camera (including a 5 × 4 inch large-format lens) so long as the front filter thread doesn't exceed 67mm, it has been designed with rangefinder cameras in mind. The holder is much smaller than a standard system to avoid blocking the user's view through the viewfinder. Additionally, it is etched with precise index markings to help with alignment of graduated filters. It also has a purpose-designed polarizing filter that can be used in conjunction with other filters in the system.

BELOW
Lee's slot-in filter system is designed to work with rangefinder cameras.

RIGHT
Despite the lack of through-the-lens viewing, filters can be used effectively with rangefinder cameras.

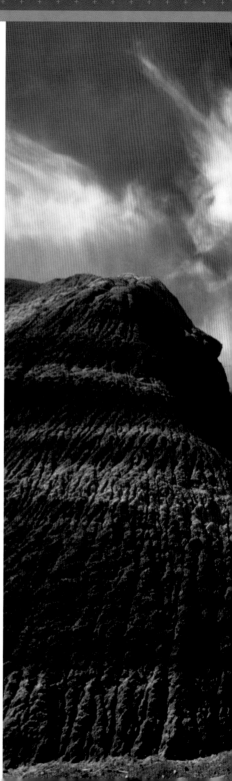

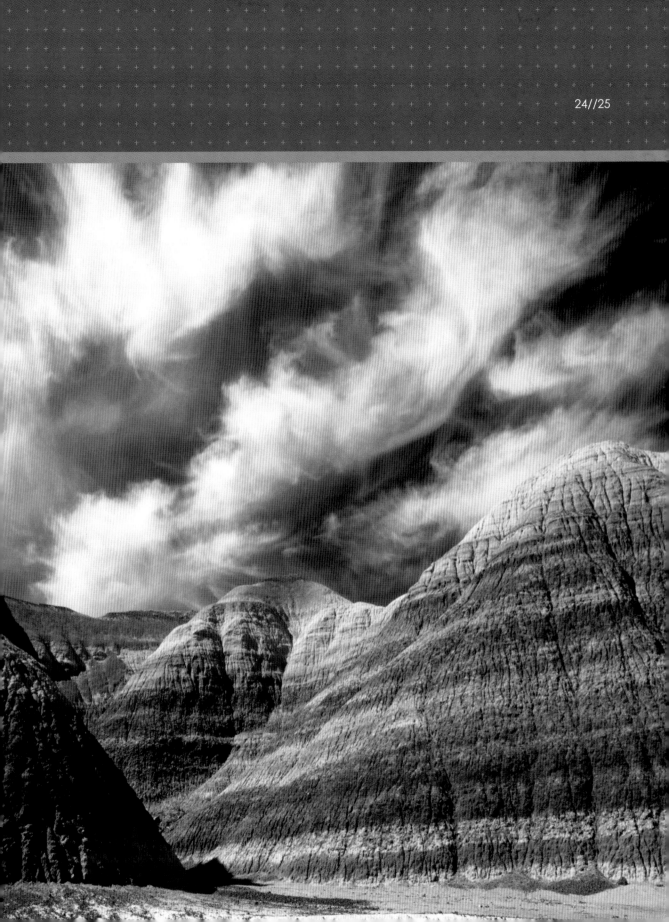

smaller; the A series being the smallest. The X-Pro series is very large and is mainly used by videographers and broadcasters.

Lee's standard series of filters and Cokin's Z-Pro series are ideal for photographers, and are big enough to cover most formats up to large format, as well as being practically insusceptible to vignetting, even when extreme wide-angle lenses are used. This makes them extremely versatile and able to grow with your camera system as you acquire additional lenses and cameras of differing formats. This advantage should outweigh the fact that they are larger and, therefore, slightly more bulky and expensive. The fact that the filters are of the same physical size makes them interchangeable between the two systems.

LEFT
Cokin's Z-Pro series filter system.

Filters come in a variety of sizes. Screw-in and drop-in filters are sized in reference to their diameter and should be matched with the diameter of the screw thread of the lens they are to be used with (either the screw thread around the front of the lens or the drop-in filter holder at the rear). So a lens with a 72mm front screw thread will need a 72mm diameter filter. This is simple enough; however, slot-in filters come in a variety of sizes and their appropriateness is less obvious.

Two of the most popular slot-in filter manufacturers are Lee Filters and Cokin. Lee's standard filters are of a professional format, measuring 100 × 100mm (square filters) or 100 × 150mm (rectangular filters). They also produce a specialist system for rangefinder cameras. Cokin, however, produces four different sized filters, named the A, P, Z-Pro and X-Pro series. The Z-Pro series replicates the size of the Lee filters, while the A and P series are

LEFT AND BELOW
Lee's standard 100mm series of slot-in filter systems. The size of the filters used in the Cokin Z-Pro and Lee 100mm systems are the same, making them interchangeable.

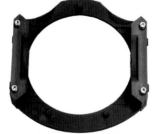

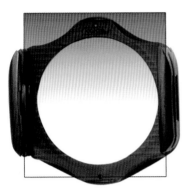

LEFT
The Cokin A series of slot-in filters are small and designed for use with small-format cameras and a limited range of lenses.

BELOW
The Cokin Z-Pro series of slot-in filters.

The Cokin A series of filters was originally designed for the amateur photographer and can only be used with lenses having a front screw thread of 62mm in diameter or less (36mm being the smallest). This limits their use with some fast lenses that have larger front diameters, including common workhorse lenses such as the 70–200mm f/2.8 telephoto zoom lens (or similar). Also, because of their small physical size (67 × 67mm), they are prone to vignetting when using wide-angle lenses.

The Cokin P series was introduced later to appeal to more advanced amateur and professional photographers (another manufacturer, Hitech, has a similar system referred to as the Hitech 85). The larger physical size of the Cokin P system filters (84 × 84mm) enables them to be used with wide-angle lenses, ranging from 20mm upward (50mm on medium format and 72mm on large format). Also, the larger size of the holder enables adaptor rings of up to 82mm to be fitted, meaning the P system can be used with almost any lens. However, they remain limited for some applications; this has led to Cokin introducing the X-Pro series, which offers a more standard and versatile filter size.

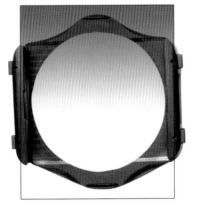

NON-PROPRIETARY FILTERS

The Cokin P series is arguably the most popular filter system used around the world, and Cokin produces over 140 different filters to fit this system. Because of its popularity, other manufacturers now also make filters to fit the system, including Singh-Ray, Tiffen, and SRB-Griturn.

LOW-PROFILE SCREW-IN FILTERS

Some screw-in filters are available in super-slim versions, which use a low-profile metal ring. These filters are specially designed for use with extreme wide-angle lenses to reduce the likelihood of vignetting.

We don't often think of filters as having accessories, but there are a few items that will add value, particularly with slot-in filter systems. The most important is the lens hood—a vital piece of kit for anyone who regularly shoots outdoors. One of the disadvantages of slot-in filter systems is their inability to attach to the purpose-designed lens hoods provided with many lenses. To overcome this, some manufacturers have developed specialist lens hoods that attach to the filter rings.

Lens hoods based on the bellows design (see image below left) are extremely practical, as they can be sized appropriately for the lens in use by simply extending or retracting the bellows accordingly. For wide-angle lenses it is possible to get a bellows-type lens hood that has a wider structure. This helps to prevent vignetting, particularly when used with a wide-angle adaptor ring, which has a lower profile (see image below middle).

Another disadvantage of the slot-in system is attaching lens caps with the holder in place. Lens caps should always be used when the camera is not in use to protect the front element of the lens from becoming scratched. However, most lens caps can't be fitted with a slot-in filter holder attached to the lens. One option is to remove the holder, which is fine if you are at the end of your shoot but inconvenient if you are simply changing location. Some manufacturers supply special lens caps that are designed to fit on the filter holder, solving this problem.

BELOW LEFT
A lens hood designed to be used with a slot-in filter system.

BELOW
A wide-angle lens hood designed to fit on a slot-in filter holder and suitable for use with extreme wide-angle lenses. The larger size of the hood's aperture prevents vignetting.

BELOW RIGHT
With a special mount such as this, two filter holders can be attached to the same lens, increasing the flexibility of the system.

ABOVE
Special lens caps can be fitted over the attachment rings, which can then be left on the lens permanently for quick attachment of the filter holder.

A further limitation of slot-in filter systems is the number of filters that can be used simultaneously. With screw-in filters, in theory any number of filters can be attached together (although there is a practical limit), whereas most-slot-in filter holders can hold a maximum of three filters. By adding a special adapter, however, multiple holders can be used together, which increases the number of filters that can be used in combination. There is always a practical limit, however.

ABOVE
A disadvantage of the slot-in type filter system is that vignetting can occur, particularly when using wide-angle lenses. To help overcome this problem, special low-profile attachment rings, sometimes referred to as wide-angle adapter rings, can be used. These sit closer to the front element of the lens and reduce the occurrence of vignetting.

BELOW
The advantage of bellows-type lens hoods is their ability to be extended to precisely the right position for the lens in use, being pushed back for wide-angle lenses and pulled forward when telephoto lenses are used (as demonstrated in the three illustrations below). This also minimizes the likelihood of vignetting occurring.

For quick and easy identification of filters, it is a good idea to keep them in an orderly manner and clearly name their pouch or holder with the filter type. This will save you rummaging around in your camera bag when speed is of the essence, as can often be the case when reacting to fast-changing lighting conditions. Once you have finished using a filter, always return it to its holder and avoid laying multiple filters on top of one another.

Filters are delicate items that are precision-made. As such, they should be handled with due care and attention. Whether storing them or carrying them around in the field, filters should always be placed in non-abrasive holders, such as a microfiber pouch, to prevent accidental marking and scratching. When removing filters from their pouch or case, always remember to hold them by their edges to avoid getting fingerprints on the surface.

If a filter does become dirty it should be cleaned in the same manner you would clean a lens. Dust and non-sticky particles of dirt can be blown off with a blower or canned air, while fingerprints can be wiped clean by breathing on the surface of the filter to moisten it, then wiping gently with a microfiber cloth in a circular motion from the center outward.

Repeated cleaning of filters, particularly resin and polyester filters, is liable to result in scuffing and scratches on the filter surface. If a filter does become scratched or permanently marked then it's time to replace it.

ABOVE LEFT
A pouch designed for storing multiple filters.

ABOVE
For transporting a large number of filters, use a multisleeve carry pouch.

STORAGE WALLETS

It is possible to purchase special storage wallets for filters that have a number of sleeves within a zip-up case. A cheaper, but equally suitable alternative, is to buy a CD/DVD storage wallet.

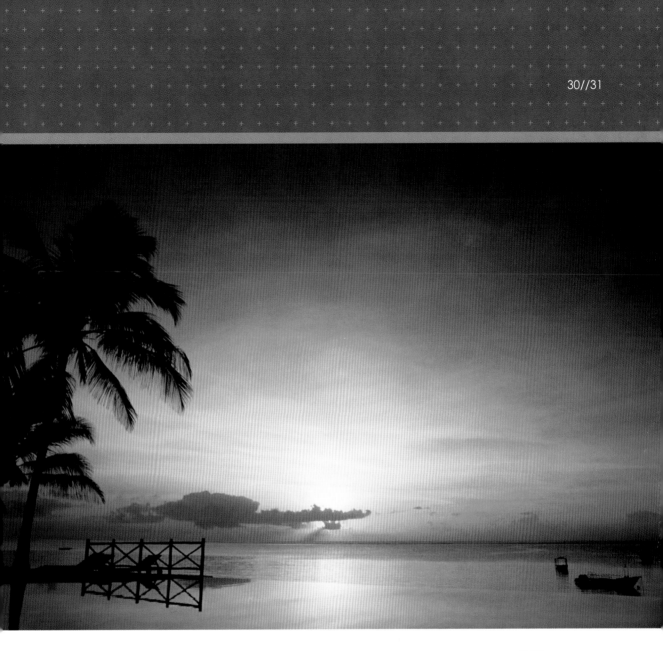

LEFT
This pouch, manufactured by Lee Filters, is made of microfiber cloth, which protects filters from becoming scratched.

ABOVE
Carefully looking after your filters will maximize image quality.

Most filters will work on a digital camera in much the same way that they work with a film camera. A true ND filter will, for example, block exactly the same amount of light from entering the lens irrespective of whether the photographic medium is digital or film. However, care should be taken when using color correction filters, such as amber warming (81 series) filters or blue cooling (80 series) filters when the WB setting on a digital camera is set to Auto mode. WB is discussed in more detail on pages 146–153; however, in relation to using optical filters with a digital camera it is important to understand that when set to Auto White Balance (AWB) a digital camera will correct any perceived color cast, whether directly from the light source, or introduced by a colored filter to produce neutral white light. Therefore, any effect of a color correction filter will be lost, as the camera will simply compensate to remove the color cast. When using optical color correction filters with a digital camera, set WB to an appropriate preset setting or dial in a suitable Kelvin value via the manual setting (see page 150).

A

RIGHT
With WB set to Auto, the digital camera has eliminated the effects of the 81B warming filter that has been fitted to the lens in image A. By setting WB to the Daylight setting in image B, the camera has processed the image differently, enabling the effects of the warming filter to show through.

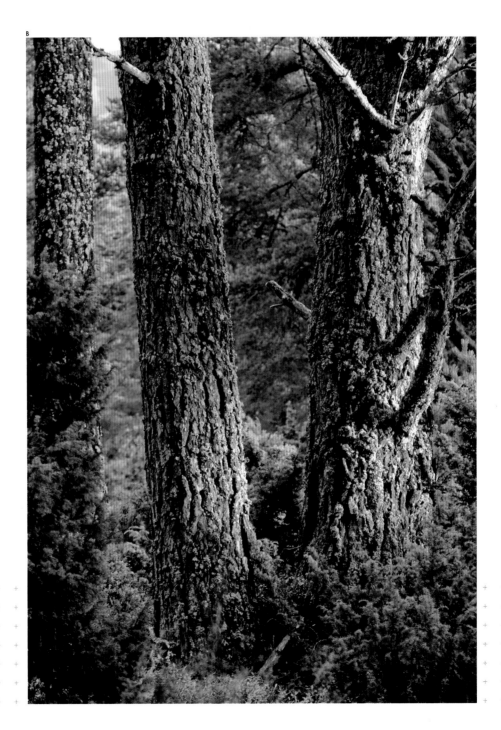

Section 2

Optical Filters

The term "good light" is used widely in photography circles, but what is considered good light and how can we recognize it? Ask this question to ten different photographers and you are likely to receive as many different answers. In reality, good light depends on the task at hand. Landscapers, for example, will point to the so-called golden light of sunrise and sunset; archivists will talk about achieving perfect neutrality; and wedding photographers will wax lyrical about soft light.

In truth, there is no such thing as "good" light; there is simply light. And with a little imagination and lateral thinking, a good photographer can turn any type of lighting situation to their advantage. In order to do so, it is important that photographers understand the basic principles of light, and in particular how a camera sees light, so that they can take the necessary steps to capture it in an aesthetically pleasing way.

Understanding light is also essential in order to make the best use of filters. As mentioned previously, the purpose of filters is to alter the characteristics of light entering the camera (see page 19); as cameras see light differently to humans, it is important to consider the effects of light invisible to us but not to the camera, such as UV light. The first section of this chapter therefore relates to light—its makeup, quality, color temperature, and intensity.

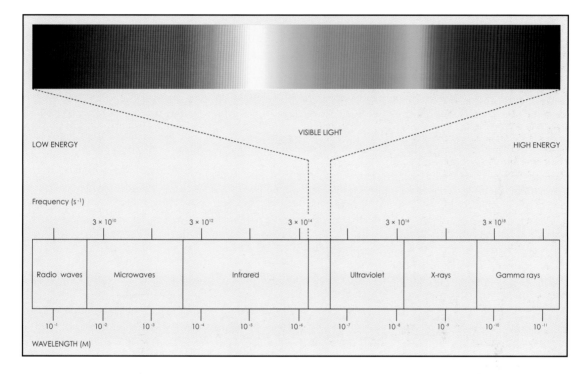

LEFT
In photography, what a landscape photographer considers flat lighting, a wedding photographer may pray for to limit contrast.

ABOVE
The spectrum of light visible to humans.

Visible and invisible light

Light is formed of different waves, the majority of which are invisible to the human eye. We can see the light waves that make up visible light, whereas photographic films and digital photo sensors are able to record some forms of light that are invisible to us, namely UV and infrared light. For example, you may have seen television programs where they have used infrared cameras to film nocturnal wildlife. These cameras are recording infrared light, enabling us to view a scene that would otherwise be too dark to see.

What is important to appreciate is that some photosensitive materials can record certain forms of light that we cannot see. And because these light waves are invisible to us, it is difficult to visualize their effects on a photographic image until after the picture has been taken and processed, either in-camera or in-computer (digital), or in a darkroom (film).

Standard photographic film is insensitive to infrared light and is therefore unaffected by its presence. In order to record infrared light, special film and infrared filters must be used (see pages 128–129). Digital photo sensors are sensitive to infrared light and so, in standard digital cameras, have a special infrared blocking filter built into their construction.

Color films and digital photo sensors are sensitive to UV light, which means that both materials will record the effects of ultraviolet light unless it is filtered out. Color film basically consists of three color-sensitive layers—one that reacts to red light waves, one to blue waves, and another to green. The blue layer responds to both visible light and ultraviolet light. If there is a lot of ultraviolet light in the atmosphere, the blue layer receives more exposure than either the red or green layer, resulting in an overall blue color cast on the image.

Most digital photo sensors work slightly differently in that they use a mosaic of red, green, and blue filters, with only one color covering an individual photosite (pixel). As with film, the blue filter is similarly sensitive to both visible and UV light, which can result in the same blue color cast as that recorded by film. However, this color cast is more easily corrected during the processing stage and can be eliminated altogether by appropriate use of the WB control (see page 146).

The technical purpose of a UV filter is to block ultraviolet light, preventing it from reaching the film or photo sensor; and thereby avoiding the associated blue color cast.

Ultraviolet light is more prevalent at high altitude than at sea level. Using a UV filter, therefore, is more necessary when photographing in a mountain environment or when undertaking aerial photography.

ABOVE LEFT
UV filters are transparent to visible light. They have multiple uses, such as reducing haze or fog created by ultraviolet light.

ABOVE
The layers that make up a modern photographic film.

LEFT
The Bayer Pattern is an arrangement of red, green, and blue pixels. It is used in most single-chip digital image sensors to create a color image.

BELOW
Ultraviolet light is more prevalent at high altitudes. Using a UV filter has resulted in a reduction of haze and more color saturation in image B when compared to image A.

Using UV filters as lens protectors

Many photographers will use a UV filter at all times to protect the front element of a lens from being scratched, marked, or getting dirty. There are two trains of thought on this practice. Those in favor argue that it is cheaper to replace a low-end filter than to repair a badly scratched front lens element. Those against argue that to place a low-end filter in front of an expensive lens would reduce its optical quality.

There are merits to both arguments. However, it's worth remembering that a well-made, high-quality filter used properly will have little visible impact on image quality. At the end of the day, it's a personal choice. I use a UV filter when photographing in particularly dusty environments or when working in conditions where there is a good chance of the lens becoming marked otherwise, I tend to work without a UV filter unless it is needed for its technical properties. When I do use UV filters I opt for a high-quality product, typically from B+W, which are made by Schneider Optics.

TYPES OF UV FILTERS

If you do intend to use a UV filter as a layer of protection then the most efficient filter type is the screw-in variety. Even when using UV filters for their technical properties, I find it easier to simply screw one onto the front of the lens, rather than fitting an entire slot-in system to the camera.

BELOW
Skylight filters (shown on the right) are often sold as alternatives to UV filters, but have a pink tinge that may introduce an unwanted color cast. On the other hand, UV filters (shown on the left) are clear.

BOTTOM LEFT
In bad weather conditions, a UV filter will protect the front element of a lens.

UV FILTERS VERSUS SKYLIGHT FILTERS

Skylight filters are often sold in place of UV filters to act as lens protectors. However, whereas UV filters are clear, skylight filters have a slight pink tinge that may add a color cast to an image. A simple test to check for filter coloration is to place the filter on a sheet of plain white paper. A clear filter will have no effect on the whiteness of the paper. A colored filter, however, will add a color cast. If you are using a filter to protect the front lens element rather than for any particular technical properties, it is advisable to select a UV filter.

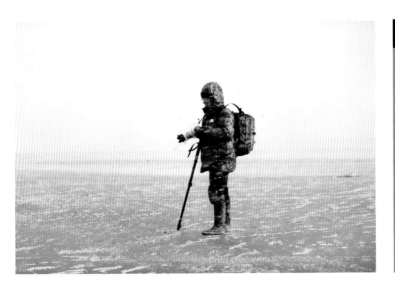

A

The term "quality of light" generally refers to contrast, and is described as being either hard or soft. Light that emanates from a point source, such as direct sunlight or non-diffused, non-reflected flash lighting, is considered hard light because it creates high levels of contrast between light and dark tones, as well as shadows that have a solid, hard-edged appearance. This type of lighting can be beneficial in that, falling from the right direction, it tends to create form and a sense of three-dimensionality. On the other hand, it can be problematic. For example, a wedding photographer presented with a bride in a white dress and a groom in a black suit will struggle to retain the detail in both outfits on a contrast-rich day, when SDR exceeds camera dynamic range (CDR).

Soft lighting, which emanates from a large source such as sunlight on an overcast day, or flash lighting filtered through a soft box or reflected off an umbrella, is low in contrast, creating weaker, softer-edged shadows. It is subtler than hard light and is often preferred by portrait photographers, as it can hide facial blemishes and give skin a softer appearance. Of course, wedding photographers prefer it because soft light almost always brings SDR within CDR. However, soft lighting can sometimes appear flat, which isn't conducive to all images, particularly when you are trying to create form and a sense of depth.

B

**ABOVE LEFT
AND ABOVE**
The quality of light
greatly affects
contrast, and can
also be described
as being soft (as seen
in image A) or hard
(as seen in image B).

CONTRAST-MANAGEMENT FILTERS

In terms of filtration, high levels
of contrast may necessitate using
contrast-management filters, such
as graduated/split filters, which are
covered later in this chapter (see
pages 50–67).

If you can remember doing metalwork at school you may recall that heating a lump of metal changes its color. First it turns red, then orange, yellow, and finally, at its hottest, white. Take the metal away from the heat and as it cools down, it follows the same color change process in reverse.

Exactly the same thing happens to the color of daylight as the sun rises throughout the day. At sunrise the color temperature of light is relatively low and has a red color cast. As the sun rises so too does the color temperature of light. From red, sunlight becomes orange, then yellow, and finally, at around midday, the color temperature of light is equivalent to neutral white light. Unfortunately, we don't perceive these color changes because humans have a built-in white balance control in our brains that make us see all light as neutral white. For example, look at a household lightbulb—to the naked eye its light appears white, but in reality it is red, as you will see if you photograph a subject using a household lightbulb as your main light source with daylight-balanced film in your camera (or if you set WB on a digital camera to the Daylight setting, which is the equivalent of daylight-balanced film).

Another external factor influencing the color temperature of natural light is weather. For example, sunlight that is diffused by light cloud cover has a higher color temperature than direct, non-diffused sunlight, causing a blue color cast. On a heavily overcast day, color temperature rises further still, with an appropriate increase in (blue) color cast.

RIGHT AND FAR RIGHT The color temperature of light changes throughout the day, being much warmer at the beginning and end of the day (image B) than at midday (image A).

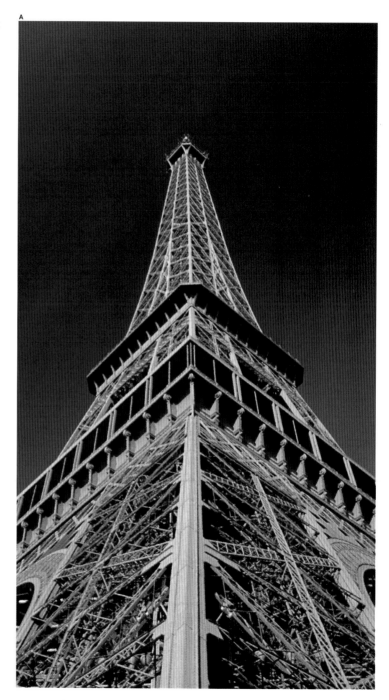
A

B

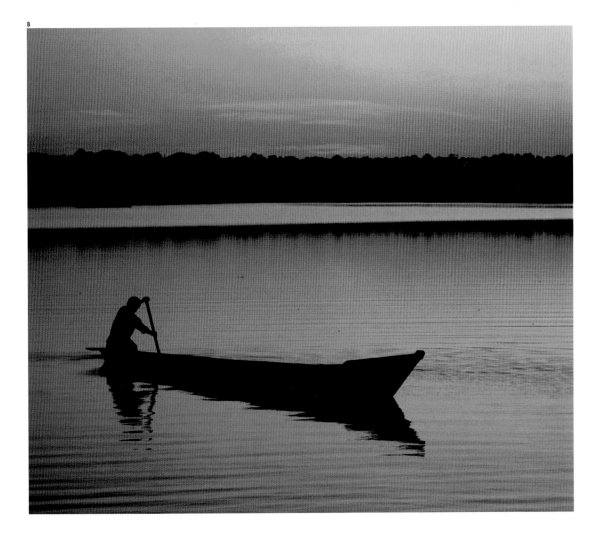

LEFT
The color temperature
of daylight changes
throughout the day,
ranging from red at
sunrise and sunset to
white around midday.

Artificial light sources also have their own color temperature characteristics, which is important for anyone doing a lot of studio-based photography. For example, electronic flash lighting is designed to have a color temperature very similar to that of daylight at midday. However, the fluorescent and tungsten continuous lighting systems used in studios vary in color temperature and are typically cooler than natural daylight (see the Kelvin scale table on page 69). Similarly, household lighting, such as standard lightbulbs and fluorescent strip lighting, also varies in color temperature.

In terms of photography, it is important to understand the effects that color temperatures have on the photographic image, and be able to compensate for them where necessary. The techniques used to achieve this are described later in the chapter (see pages 68–71).

B

**ABOVE LEFT
AND ABOVE**
Tungsten light has an
orange cast, shown
in image A. Filters can
be used to neutralize
this cast to achieve
the more natural look
shown in image B.

Light intensity is affected by the size of the light source and its distance from the subject. While the sun is a long way from Earth, it is very large and, when unobscured, extremely intense. In comparison, an electronic flash unit is relatively small, but if placed 6in (15cm) from an object will still create a very intense light. To reduce its intensity you would need to cover the flash unit with a diffuser in order to create a larger light source.

When using artificial lighting it is possible to alter intensity by simply changing its quality (see page 40) or by moving it closer or further away from the subject, but it is much harder to change the intensity of daylight. In some cases it may be possible to place a large diffuser between the sun and the subject, but this solution is often impractical. It may be feasible to return to the scene on a later day when weather conditions have changed, but again, this isn't always possible.

Using a suitable filter may be the only workable solution when it is impossible or impractical to change the intensity of light. An example of this in practice is described on page 65.

A

B

ABOVE
Filters can be used to reduce shutter speeds when the intensity of light is too great for the effect required, such as when wanting to blur the movement of water, as seen in images A and B.

RIGHT
When photographing in natural light it is often impossible to change the intensity of light at any given time.

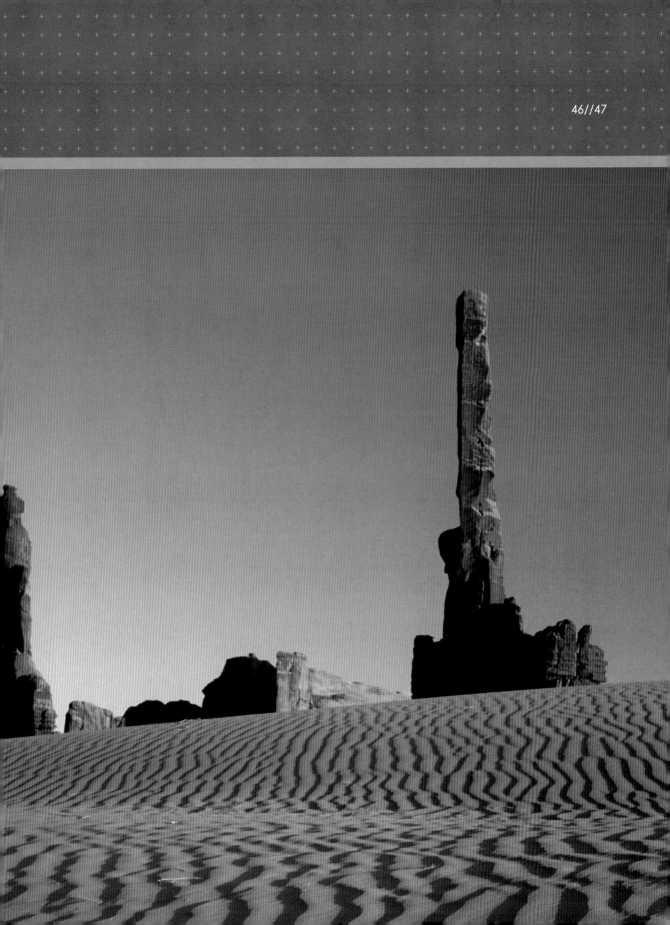

LEFT
This screenshot, taken with Adobe Camera Raw, shows areas of excessive contrast. Featureless shadows are highlighted in blue, and washed-out highlights without any detail are shown in red.

RIGHT
Wedding scenes that involve a bride in a white dress and a groom in a black suit are a good example of non-linear contrast.

To an extent, the various characteristics of light can all be managed and controlled. Different filters do different jobs and even filters in the same group can vary in their applications. The following pages cover the technical filters that provide photographers with the means of dealing with contrast, intensity of light, and changes in color temperature.

Managing contrast

Contrast refers to the range of brightness in a scene. A scene where there is a difference between the brightest and darkest tones is said to be low in contrast, whereas a scene with a much greater range of brightness is said to be contrast-rich. Photographically, contrast creates form and a sense of depth. Without contrast a photographic image will appear flat and two-dimensional. A problem arises, then, when the level of contrast in the scene being photographed (SDR) exceeds the camera's ability to record it (CDR). When SDR exceeds CDR some tones in the scene (either the brightest or darkest tones, or a combination

of the two depending on how the exposure is set) will be recorded devoid of detail, i.e. areas of shadow will be rendered featureless black and/or areas of bright highlights will be washed out.

Contrast can be described as being linear or non-linear in nature. An example of linear contrast is a scene where there is a gradual increase in brightness from the foreground to the background of the image space, such as a landscape scene with a uniform area of shadow in the foreground increasing in brightness to a well-lit sky. An example of non-linear contrast is a wedding scene that includes a bride wearing a white dress with the groom in a black suit standing to one side. Non-linear contrast is close to impossible to manage using filtration and must be combated using other techniques, such as defusing the light source. Linear contrast, on the other hand, can be managed using graduated/split filters.

DIGITAL CLIPPING

In digital terms, the reproduction of tones having no visible detail is referred to as clipping, as in clipped highlight pixels or clipped shadow pixels.

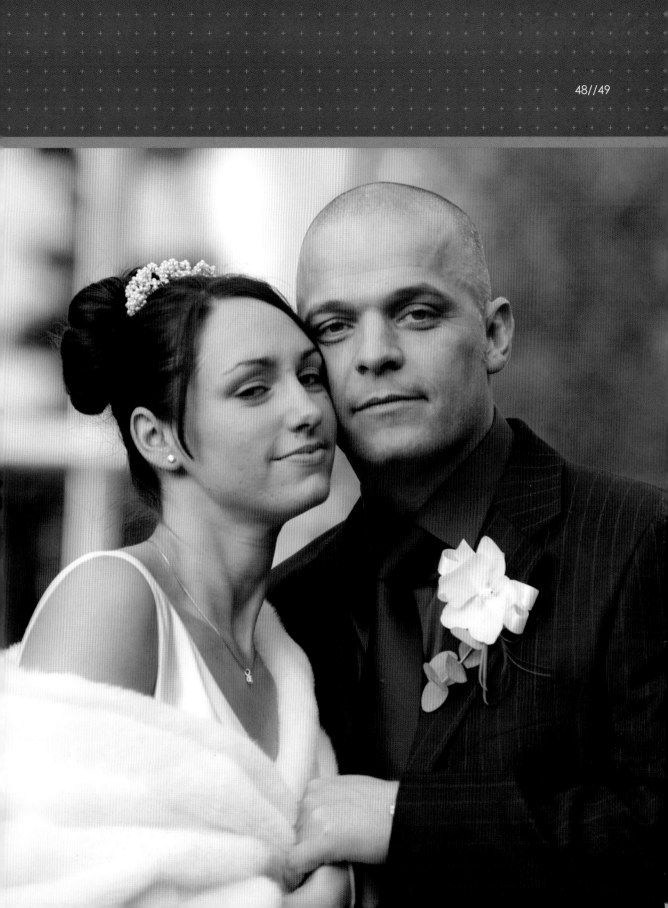

GRADUATED NEUTRAL DENSITY (GND) FILTERS

The most common means of managing linear scene contrast is to use a GND filter. The purpose of GND filters is to reduce exposure in a selected area of the scene without affecting color balance (hence the term "neutral density").

GND filters come in different densities (different levels of absorption) and with a hard or soft transition. Strength is measured using the standard photographic unit of stops (see table below), with 1-stop, 2-stop, and 3-stop strength filters available. It is possible to combine individual filters in order to create greater densities. For example, adding a 1-stop GND filter to a 3-stop GND filter will create one of 4 stops in strength. Adding a 2-stop to a 3-stop gives a combined total of 5 stops.

The type of transition is also important. With a hard GND filter the transition between the clear and dark sections is sudden, with a distinct line denoting the start point. Conversely, a soft GND filter has a more gradual transition from clear to dark, and the start point is less apparent. This introduces a technical consideration. With a soft GND filter the transition from clear to dark is gradual, with only a portion of the dark part of the filter at full strength (usually the upper third), whereas with a hard GND filter the whole of the dark portion provides almost the same level of absorption.

The problem caused by this distinction can be illustrated using a practical example. GND filters are most often used to reduce the exposure in skies. However, most skies tend to be brighter the closer they are to the horizon. Say you are using a 2-stop GND filter with a soft transition—because the transition to the full 2 stops' strength is gradual, the brightest area (the horizon) is likely to be covered by

the part of the filter where the level of absorption is lowest, making the filter less effective.

One solution is to drop the filter in the holder so that the upper (darker) portion covers the horizon. However, this creates a new set of problems. First, an area of the foreground will be covered by the middle portion of the filter where some absorption is taking place, which may result in that part of the scene being underexposed. If the filter is dropped too low in its holder the very top of the image space may be uncovered, resulting in a band of brighter sky at the top of the frame.

0.6 ND Hard

0.6 ND Soft

0.3 ND

0.45 ND

0.6 ND

0.75 ND

0.9 ND

GND FILTER DENSITIES	
Notation	**Strength**
0.3	1 stop
0.45	1.5 stops
0.6	2 stops
0.75	2.5 stops
0.9	3 stops

ABOVE
A set of ND and GND filters.

RIGHT
Lowering the GND filter in the holder so that it covers more of the image space may help solve the problem of non-uniform levels of brightness in the sky, but can create inherent problems.

FAR RIGHT
Using a hard GND filter will help to overcome the problem of non-uniform levels of brightness in the sky.

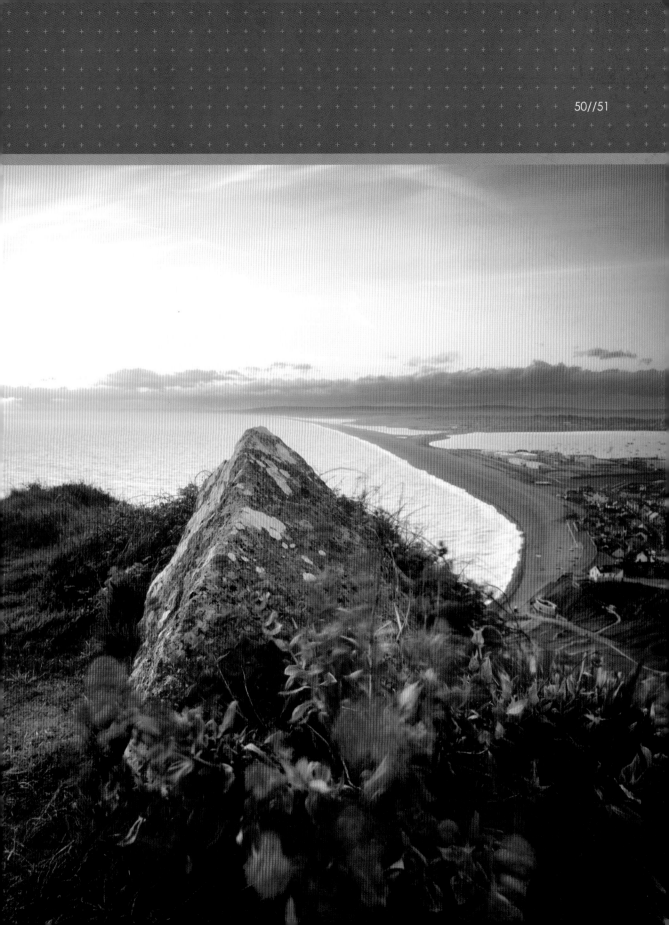

A hard GND filter will solve the problem described on the previous page because, in practical terms, it has a uniform level of absorption across the whole dark half of the filter. By placing the distinctive transition line at the exact position of the horizon line, the whole area of sky will be affected by the same level of absorption without the foreground being affected.

BELOW
Using a tripod out in the field makes working with GND filters far easier and helps achieve best results.

Hard transition GND filters have their disadvantages, though. First, careful attention must be paid to their placement. Because the transition is sudden, even slight misalignment can result in an obvious band of brightness across the image. Also, they are very effective when the horizon line is unbroken. However, if an area of foreground, such as a rolling hill, juts into the skyline, a hard GND filter will create a distinct unnatural line across the landform. Using a soft transition GND filter solves both of these problems.

Using GND filters in the field
In order to use GND filters accurately, the camera should be used in conjunction with a tripod. It is possible to handhold a camera and still make use of GND filters, but to do so means everything is done one-handed, as you try to position the filter and hold the camera. Coupled with slight changes in camera position, this makes the whole process imprecise. To achieve the best results, always try to use a tripod.

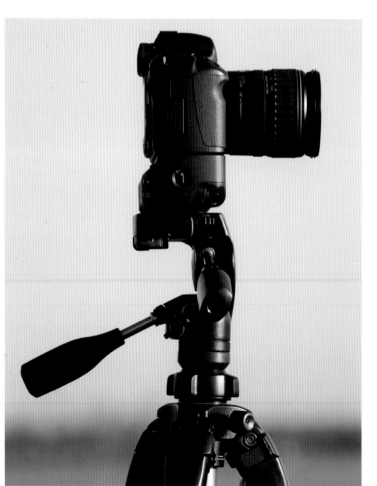

GND VERSUS GRAY FILTERS

A true ND filter (whether graduated or full) will not alter the color cast of the light passing through it. Some ND and GND filters are instead referred to as gray (or graduated gray) filters because they are not truly neutral, and may add a color cast to the image.

TYPES OF GND FILTERS

Slot-in GND filters are preferable to screw-in types, as the flexibility provided by the filter holder enables the transition line to be positioned up or down the picture space. They can also be used more easily at an angle and even upside down. With screw-in GND filters, the transition line always cuts across the middle of the picture space, which reduces the compositional options of placing the horizon line in the upper or lower portion of the frame.

RIGHT
When the horizon line is broken, a hard-edged graduated filter will leave a line (see image A). A soft-edged graduated filter will overcome this problem (image B).

A

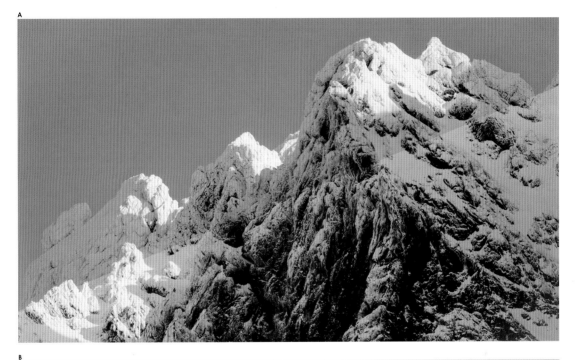

B

GND filters come in different densities or strengths (see table on page 50), so the first decision you will need to make is the density you require.

To illustrate how to assess the correct filter density I am going to look first at the most common scenario where a GND filter is likely to be used—a landscape scene where the foreground is in shadow and the sky is brightly lit. This is likely to occur when photographing early in the morning or late in the afternoon (the ideal times for shooting landscape photography), when the sun's angle is low to the ground.

What you are trying to do by using a GND filter is balance the tone of the sky with that of the foreground. Included here is a step-by-step technique to follow. The preferred method for assessing exposures when using a GND filter is to use a handheld manual spot meter. However, in this scenario I am assuming that the camera's built-in through-the-lens (TTL) light meter is being used. If using a handheld spot meter you can still follow much the same process.

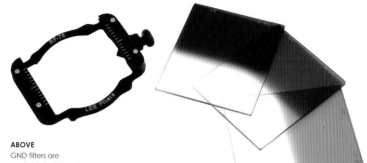

ABOVE
GND filters are available in different strengths (densities), typically between 1 and 3 stops.

1. Set the camera's metering mode to Spot (see opposite page for alternatives to spot metering mode) and the exposure mode to aperture priority AE (automatic exposure).

2. Set the lens aperture to the working value (e.g. f/16 or f/22, etc.).

3. Holding the camera, point it at an area of midtone in the foreground, take a meter reading, and note the suggested shutter speed for the aperture you have set.

If there is no obvious area of midtone, take a meter reading of the lightest area in the foreground, then the darkest area, and average the two values. For example, if the exposure for the lightest area is 1/30 at f/11 and the darkest area is 1/8 at f/11, the average would be halfway between the two readings, i.e. 1/15 at f/11. For the most accurate TTL spot meter reading, use a longer focal length lens or zoom to a longer focal length to minimize the amount of the scene visible in the viewfinder. Revert to the working focal length before taking the reading.

4. Without altering the lens aperture value do the same for the sky, again noting the camera's suggested shutter speed.

5. Calculate the difference in stops between the two shutter speed values (the one for the foreground and the one for the sky). The difference between the two values equates to the density of the GND filter you should use. For example, if the shutter speed for the foreground is 1/15 and for the sky 1/60 then the difference is two stops, equating to a 2-stop (0.6) GND filter.

If the difference in stops is fractional, choose the closest lighter density of filter. For example, if the difference equates to 1.5 stops, select a 1-stop (0.3) density GND filter.

6. Set the camera's exposure mode to Manual and the shutter speed to the value given for the foreground reading (in this example it would be 1/15), making sure to leave the lens aperture value unchanged.

7. Set the camera on a tripod, compose the image, accurately place the GND filter, and take the picture.

If your camera doesn't have a spot meter facility you can still use the built-in meter by pointing the camera at

the shaded area of the scene and then at the sky, ensuring that neither encroaches on the other. Although a less exact method, it will give you an assessment for exposure that is close enough.

This example illustrates using GND filters to help even lighter tones with darker tones. There are occasions when you may prefer some variance. For example, over-darkening a stormy sky will add a sense of drama to the scene. Using the step-by-step instructions on the previous page, at step 5 you would select a 3-stop (0.9) density GND filter in this scenario.

Similarly, if the sky is naturally brighter than midtone, as it generally is in the morning, you may want to maintain the difference in tone by choosing to use a less dense GND filter. Again using the above instructions, at step 5 you would select a 1-stop (0.3) density GND filter in this case.

The level of variance in brightness between the shadow and highlight areas is arbitrary and it is up to you to decide. The purpose of GND filters is to give you the ability to manage tonal variance to the desired extent. What is important to ensure is that the total brightness range remains within

the camera or film's ability to record it (dynamic range/latitude), otherwise the brightest areas of the scene will become washed out, white, and without detail, or the shadow areas will show as featureless black.

BELOW
A GND filter has been used here to add intensity to the sky, creating a dramatic image.

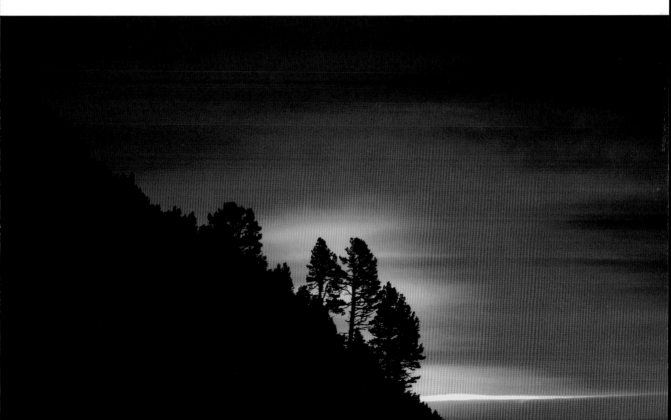

Understanding stops

A stop is simply a unit of measurement relating to light, equating to a doubling or halving of quantity of light (lens aperture), duration of exposure (shutter speed), or film sensitivity (amplification of light signal in digital), which is given as the ISO value. So, in the same way that we use feet and inches or centimeters and meters to define distance, stops are used to enable us to work with light in a logical and measurable way.

For example, on a lens (or in the camera's LCD screen) the standard f-numbers representing different-sized lens apertures might show as follows (the exact range will depend on the lens used):

**f/2.8 > f/4 > f/5.6 > f/8 >
f/11 > f/16 > f/22**

The difference in the quantity of light passing through the lens between f/2.8 and f/4 is equivalent to a 1-stop difference; between f/4 and f/5.6 it is also 1 stop, as it is between f/5.6

and f/8, f/8 and f/11, and so on. In this sense, as photographers we don't need to understand how any given f-number was arrived at, but simply that the difference between one number and the next is equal to 1 stop (one unit of measurement).

The same theory applies to shutter speeds. Most cameras have many shutter speeds, ranging from around 30 sec to 1/4000 sec (again, the exact range will depend on the camera). In film SLR cameras these are shown on a dial on a camera body in a sequence like the following:

**1 > 1/2 > 1/4 > 1/8 > 1/16
> 1/30 > 1/60 > 1/125 >
1/250 > 1/500 > 1/1000**

As with f-numbers, each incremental increase or decrease in shutter speed represents a 1-stop change, which in this case is the duration of the exposure. (For aesthetic purposes, some of the shutter speeds shown are written inexactly, e.g. 1/30 instead of 1/32.)

Changes in ISO ratings are also measured in terms of stops. The following sequence of ISO numbers are written in 1-stop increments relating to amplification:

**100 > 200 > 400 > 800 >
1600 > 3200**

What the stop system enables photographers to do, then, is make changes to lens aperture, shutter speed, or ISO by a specific and quantifiable amount.

FRACTIONS

Stops have become more complicated as cameras have evolved, insofar that adjustments in each of the exposure controls can now be made not just in full 1-stop increments, but also in 1/2-stop or even 1/3-stop increments. For example, the range of f-numbers available with a DSLR camera set to show adjustments in 1/3-stops would show as:

f/2.8	f/3.2	f/3.5	f/4	f/4.5	f/5	f/5.6	f/6.3
f/7.1	f/8	f/9	f/10	f/11	f/13	f/14	f/16
f/18	f/20	f/22					

If incremental changes were made in 1/2-stop adjustments, then the f/number scale would show as follows:

f/2.8	f/3.3	f/4	f/4.8	f/5.6	f/6.7	f/8	f/9.5
f/11	f/13	f/16	f/19	f/22			

The same 1/3-and 1/2-stop incremental adjustments are also available for shutter speeds and ISO. Selecting between 1/3, 1/2, or 1stop adjustments can be done via the camera's menu options.

MULTI-SEGMENT METERING MODES

Manufacturer	Name
Nikon	Matrix
Canon	Evaluative
Sony (Minolta)	Honeycomb
Pentax	Multi-segment
Olympus	Multi-segment

RIGHT
This image shows the variances in tone and contrast.

ASSESSING MIDTONES AND TONALITY

In the landscape, many commonly occurring subjects are medium tone (such as green grass and a blue sky). Some subjects are brighter than medium tone (daffodil yellow and the palm of a human hand), and some are darker (conifer green and dark gray). A useful habit to get into when learning how to assess tonality is to carry a Kodak gray card with you, which can be purchased from most large photographic retailers. In the field, hold up the card and compare its tone to the tone of the subject. With the gray card as your reference it is relatively simple to assess whether the subject is medium tone, or lighter or darker than medium tone.

A quick and simple method

If you prefer to avoid going through the process described opposite and want a quick and simple method for applying GND filters, try the following:

1. Set the camera on a tripod and compose the image.

2. Set the camera's metering mode to multi-segment metering.

3. Accurately position a 2-stop (0.6) density GND filter in the filter holder.

4. Set the exposure using the camera's suggested exposure values.

5. Take the picture.

This isn't the most accurate method for using GND filters and I strongly recommend following the full process described on page 54. However, if you're short of time or simply want to get used to using graduated filters before going on to more advanced techniques, then this step-by-step exercise is not a bad starting point.

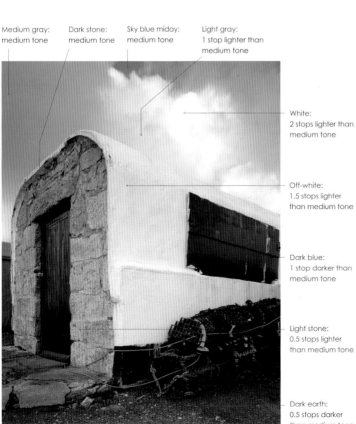

Medium gray: medium tone

Dark stone: medium tone

Sky blue miday: medium tone

Light gray: 1 stop lighter than medium tone

White: 2 stops lighter than medium tone

Off-white: 1.5 stops lighter than medium tone

Dark blue: 1 stop darker than medium tone

Light stone: 0.5 stops lighter than medium tone

Dark earth: 0.5 stops darker than medium tone

BROKEN HORIZONS

When photographing a scene with a broken horizon, any object above the transition line of the GND filter will be affected by the filter. Using a soft transition GND filter will lessen the effects on the area immediately above the horizon (or transition) line, making the effect less obvious. Alternatively, apply the GND filter in the normal way. Unduly affected objects can then be lightened during post-capture processing, using selective exposure techniques.

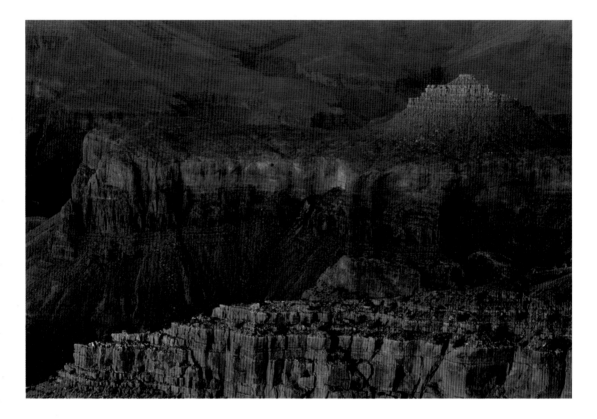

So far I have only talked about the most obvious use for GND filters—balancing variations in brightness between the sky and the foreground—however, there are many other scenarios where these variances can occur in more complex ways.

For example, imagine a landscape scene where the main subject is a mountain. It is quite possible that an area of sky on one side of the mountain is much brighter than an area on the other side. In this scenario, using a GND filter in the traditional way wouldn't be effective as it would absorb light from both areas of sky and the mountain to the same extent.

The solution for this scenario would be to angle the filter so that it covers only the bright triangle of sky to the side

of the mountain. This is the technique I used to photograph the image shown far right. In the original scene, the area of sky to the left of the mountain (as viewed) would have looked washed out had I not used a GND filter. By applying a filter angled so that the transition line runs parallel to the left edge of the mountain, I have managed to retain detail in the brightest areas of the sky.

Similarly, GND filters can be used inverted to darken overly bright areas of foreground that might otherwise dominate a scene, or with the transition line running vertically rather than horizontally, such as to darken one half of a street scene.

ABOVE
A GND filter was used inverted to take this image, in order to darken the bright foreground and balance it with the darker background.

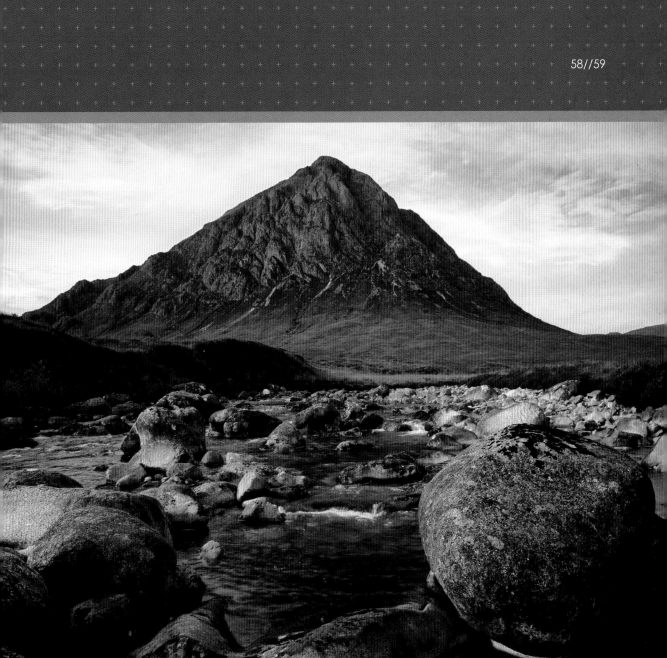

ABOVE
In the above image the area of sky to the left of the mountain was much brighter than the area to the right. To balance the exposure, I used a GND filter set at the angle, demonstrated left.

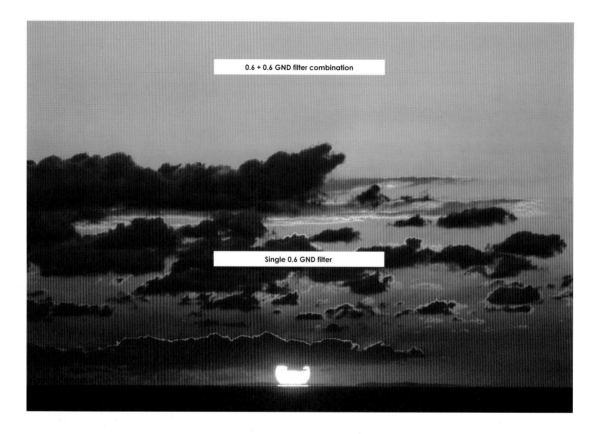

0.6 + 0.6 GND filter combination

Single 0.6 GND filter

There are scenarios when it may be necessary to use a combination of GND filters. An obvious example is a landscape scene early or late in the day, when the brightness of the sky close to the horizon is much greater than its brightness higher up in the atmosphere. In this scenario, it may be necessary to use different densities of GND filter for the different levels of brightness.

Consider the following example:
Imagine a landscape scene where low-lying clouds are obscuring the sun. In this scenario there are three distinct areas of brightness:

 Shaded foreground
 Partially shaded sky (middle ground)
 Bright sky (far background)

To assess the brightness range we can take three separate meter readings—one for each of the different areas of brightness—which may result in the following exposure settings:

 1/15 at f/11 (foreground)
 1/60 at f/11 (middle ground)
 1/250 at f/11 (far background)

In this instance, if we only use a single GND filter with a density of 2 stops, while the middle area of sky will be balanced with the foreground, the upper (brighter) area will still be 2 stops brighter.

To solve this problem, we could use two GND filters together, but stagger them. In this scenario, we would first place a 2-stop GND filter

so that the transition line met the horizon line. Then we could add a second 2-stop GND filter, positioning it so that the transition zone covers just the brighter area of sky. This would give us 2 stops of density in the middle ground and 4 stops in the far background. When staggering GND filters, it is advisable to use a soft graduation filter.

ABOVE
Multiple GND filters were used to manage the high contrast range in this scene.

RIGHT
Multiple GND filters were used to capture this image in order to balance different levels of brightness in the clouds (top right corner) and the side of the mountain lit by the sun (left edge).

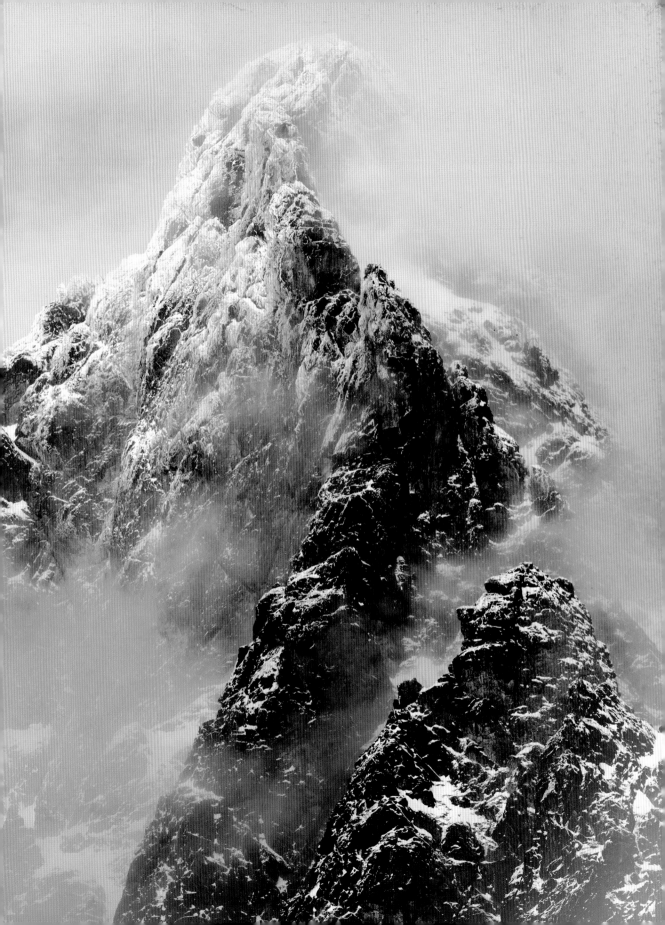

LEFT
Accurately aligning
the transition zone is
an essential, albeit
challenging, task.

BELOW
When using non-reflex
cameras, aligning
the transition zone
often involves
educated guesswork.

An important aspect of using GND filters is the accurate alignment of the transition zone. This is easier said than done, as the effects of the filter are not always obvious when looking through the viewfinder. This is particularly the case with soft transition filters. To reiterate an earlier point, it is far easier to accurately position a GND filter if the camera is set on a tripod. Also, it is easier to assess the portion of the frame over which the filter is having an effect when using hard transition filters, as the change is more sudden and pronounced.

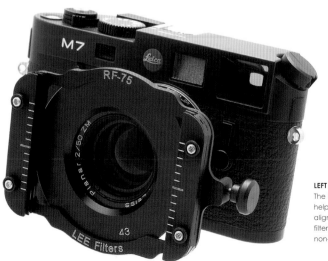

LEFT
The Lee RF75 system
helps with the
alignment of GND
filters when using
non-reflex cameras.

To align a GND filter, slot it into the filter holder. Then, while looking through the viewfinder, gradually drag the filter down, keeping a careful eye on the brightness of the image. It may help to set a small lens aperture and press the depth of field preview while doing this (if your camera has one).

If using a hard transition GND, the darkening caused by the filter should be obvious, even with a 1-stop (0.3) density filter. Soft transition filters are harder to gauge, and you may find you need to push the filter up and down within the holder before the point of transition becomes apparent.

Accurate alignment for rangefinder cameras

The technique for aligning the transition described above works well with SLR and DSLR cameras, as well as view cameras, where you see what has passed through the lens via the viewfinder or on the screen. With a rangefinder camera, however, the viewfinder doesn't show through the lens view, and it is therefore impossible to gauge placement of the filter via the viewfinder.

For many years I have used a tried-and-tested technique for aligning GND filters when using a rangefinder camera, demonstrated in the following step-by-step guide:

1. Set the camera on a tripod and compose the image in the finder.

2. Visually assess how much of the image space contains the area of sky, e.g. half, the top third, etc.

3. Using a filter holder, slot in an appropriate density GND filter (a soft transition is best).

4. Looking at the lens head, position the filter so that the area covered by the dark zone equates to the amount of the image space covered by the sky.

For example, if the sky forms half of the image space, position the filter so that the transition line cuts across the middle of the lens. If the sky takes up the top third of the image space, position the filter so that the dark part covers the upper third of the lens, and so on.

It's not an exact methodology, but with a little practice this technique is remarkably accurate.

Lee Filters have recently introduced a slot-in filter system called the RF75, which is designed to work specifically with rangefinder cameras. The system holder has laser-etched markings that correspond to fractions of the frame, enabling relatively accurate positioning of GND filters even though their effects cannot be viewed through the lens.

COMBINATION GND FILTERS

In landscape photography, it is not unusual to want to use a GND filter at the same time as an 81 series warming filter. To avoid using two separate filters, which has twice the potential to degrade image quality, it is possible to purchase a filter that combines any one density of a graduated filter with any one strength of a warming filter. For example, you could have a 0.6 (2-stop) GND plus 81B combination filter. Of course, with three different densities of GND filter and five different strengths of 81 series filter there are 15 possible combinations, which is a little impractical for most users. However, having one or two filters that combine commonly used values, e.g. 0.6 GND plus 81B, may prove to be worthwhile.

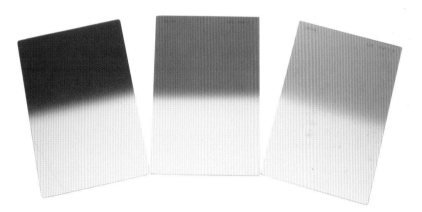

BUYING FILTER SETS

GND filters are commonly sold in sets, which include 1-stop (0.3), 2-stop (0.6), and 3-stop (0.9) densities. It is typically cheaper to buy a set than it is to buy individual filters. However, if you don't want to buy a complete set, then getting a 1-stop and 2-stop GND filter will give you the greatest flexibility, as they can be used together to make 3 stops of density.

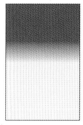

ABOVE
Rather than buying the same filters individually, GND filters are often sold in sets of three, making them more affordable.

TOP
A set of combination GND filters.

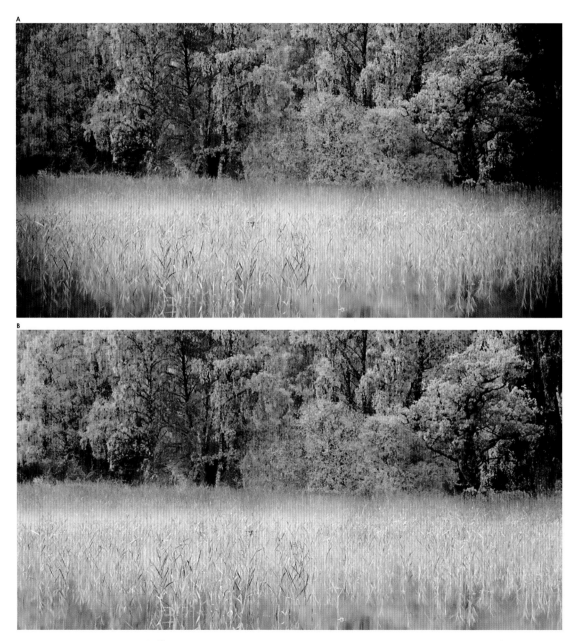

ABOVE
Light falling off an image can cause vignetting (see image A), which can be compensated for using a center-spot GND filter, as demonstrated in image B.

When using an extreme wide-angle lens on a panoramic or large-format camera there is the potential that light falling off will cause vignetting, i.e. the edges of the image will receive less exposure than the center of the image. This is because the field of view of the lens is close to or equals its image circle.

A center-spot GND filter can be used to compensate for light falling off. This type of filter is clear around the edges, graduating to a dark spot of around a 1- or 2-stop density in the center. When positioned over the lens, the filter effectively reduces the exposure at the center of the frame, balancing the level of illumination for an even exposure across the frame.

Center-spot GND filters are typically made by the lens manufacturer to fit a specific lens, each lens having its own filter with exactly the right amount of density.

If you never use panoramic or large format cameras with extreme wide-angle lenses then you will have little use for one; however, if you do use these types of cameras and lenses, then this is an essential filter to keep in your kitbag.

Managing light intensity

The intensity of light will affect exposure values. Generally, available light is of a level that enables a sufficient degree of flexibility when selecting lens aperture and shutter speed values. However, there are times when light levels are too low or too high for the desired exposure settings. In the event of the former, there is little that can be achieved with filters. However, filters are able to help when the intensity of available light is too high.

Let me describe a common example. You are photographing a waterfall on a bright day. You want to set a slow shutter speed to blur the movement of the falling water in order to give it a veil-like appearance. However, because the light is so bright, the slowest shutter speed you are able to set (assuming that lens aperture and ISO are at their minimum values) is 1/30—too fast to create the visual effect you want to achieve. What you need is a way of reducing the level of light to achieve a slower shutter speed.

Here's another scenario. Say you want to isolate the main subject of your image by blurring background and foreground detail that would require a large aperture setting (e.g. f/2.8 or f/4). In bright conditions it may be impossible to set such a large aperture and achieve the desired shutter speed. Again, the need here is to reduce the overall exposure.

A

B

RIGHT
Waterfalls are a classic example of the limitations that bright conditions present. Image A was taken without an ND filter; adding the filter to image B allowed for a slower shutter speed, therefore blurring the movement of the water.

The solution to both of the scenarios described on the previous page is to use an ND filter. ND filters are similar to GND filters, except they block a uniform amount of light across the whole area of the filter rather than graduating in density. ND filters, therefore, enable the setting of slower shutter speeds or wider lens apertures by reducing the level of light entering the lens.

As with GND filters, ND filters are available in different densities (see table below) and can be used individually or in combination to achieve the desired level of light loss. For example, taking the first scenario described on the previous page, in order to achieve a shutter speed of 1 sec (approximately the right speed for the desired effect), exposure duration needs to be reduced by 5 stops (the difference between 1/30 and 1 sec). In this instance, combining a 0.6 (2-stop) and a 0.9 (3-stop) ND filter would result in a total of a 5-stop reduction in illumination, giving a shutter speed of 1 sec.

Lens aperture would be affected in the same way. For example, if the widest achievable aperture for the light conditions is f/11, using a 0.9 (3-stop) ND filter would reduce it to f/4.

Calculating exposures
The simplest way to calculate exposures when using an ND filter is to use your camera's built-in TTL meter (if it has one). Because a TTL meter measures light coming in through the lens, it will take account of the fact you have an ND filter attached, and return an appropriate exposure value.

If you are using a handheld or non-TTL meter, the simplest method for calculating exposures is to take a meter reading and then reduce the given exposure by the density of the filter, either via the auto-exposure compensation function or by manually setting the exposure on the camera.

For example, let's say you are using a 0.3 (1-stop) ND filter. If the meter reading from a handheld light meter was stated as 1/60 at f/11, then the actual exposure would be either 1/30 at f/11 or 1/60 at f/8. This can be set manually with the camera in Manual exposure mode or by setting exposure compensation to +1 stop with the camera in any of the AE mode settings.

To calculate the appropriate density of filter to use, simply take a meter reading and work out the difference between the metered value and the desired value. For example, if the meter returns an exposure of, say, 1/30 at f/22 and you want to set a shutter speed of 1/2 at f/22, then the difference is 3 stops.

ND FILTER DENSITIES	
Notation	**Light loss (exposure increase)**
0.3	1 stop
0.45	1.5 stops
0.6	2 stops
0.75	2.5 stops
0.9	3 stops

TYPES OF ND FILTERS

Because ND filters have a fixed density across their entire surface, screw-in types are as practical as slot-in filters. If you already have a slot-in system it would make sense to use slot-in ND filters, for no other reason than consistency. However, screw-in filters are smaller and lighter, so this is also something to consider.

ABOVE
ND filters are available in different densities and can be used individually or in combination to achieve the desired level of light loss.

Using polarizing filters to manage light intensity

While polarizing filters are not ideal tools for reducing exposure values, they can sometimes be used for this purpose. A polarizing filter will absorb around 2 stops of light, depending on its rotation. So, if you need to reduce shutter speed or increase lens aperture to a value beyond the maximum achievable under the prevailing light level, attaching a polarizing filter will help.

The reason to avoid using a polarizer in this way is because not all polarizers are neutral and you therefore may introduce a cool (blue) color cast. If shooting digitally, this is easily fixed during post-capture processing or via the WB control on the camera. For advice on calculating exposure when using polarizing filters, see page 92.

BUYING FILTER SETS

As with GND filters, ND filters are commonly sold in sets, which include 1-stop (0.3), 2-stop (0.6), and 3-stop (0.9) densities. Again, if you don't want to buy a complete set, then getting a 2-stop and 3-stop ND filter will give you the most useful range.

0.3 ND 0.45 ND 0.6 ND 0.75 ND 0.9 ND

BELOW
Polarizing filters can be used to manage light intensity but are less precise than true ND filters when non-TTL meters are used.

RIGHT
Using a polarizing filter to saturate the colors in this image had the added benefit of enabling me to use a slower shutter speed, which has blurred the movement of water in the foreground.

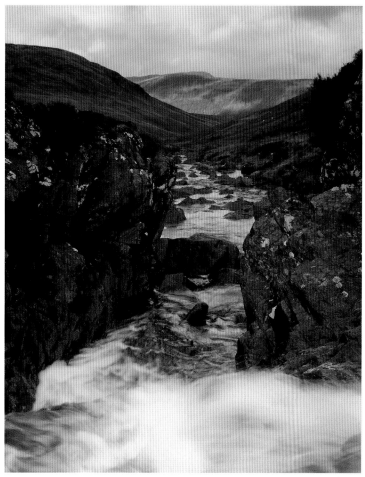

MANAGING COLOR TEMPERATURE

Photographic film is sensitive to color temperature and will record the color temperature of light as it appears unless steps are taken to nullify potential color casts. This can mean using film balanced for a different light source—for instance, using tungsten-balanced film with tungsten lighting, or using color temperature adjustment filters to convert the color characteristics of the light source to match the film type.

Digital photo sensors are equally sensitive to color temperature. However, in digital cameras the color characteristics of any light source can be balanced in-camera using the WB control, alleviating the need to use optical filters (although not necessarily preventing their use).

There are times when it is desirable to allow some, or all, of the cast from different color temperatures to show through. For example, in landscape photography a slight warming of the scene—the result of a red, orange,

or yellow color cast—is often seen as something positive. In some other genres of photography, however, where a true representation of color is important, color casts are undesirable. An example would be fashion photography, where the designer's choice of colors are intrinsic to the design, or archival photography, where the colors in ancient artefacts need to be precisely recorded.

Artificial light sources, including electronic flash lighting, fluorescent lighting, and tungsten lighting, all have different color temperatures. For example, the color temperature of electronic flash is similar to that of daylight. This is because flash lighting is designed to be very similar in its appearance and behavior to direct sunlight. However, tungsten lighting, as already described, has a low color temperature and a red color cast, while fluorescent lighting has a greenish-blue tinge, the extent of which varies depending on the source.

In all cases, the color temperature of the light source, whether natural or artificial, must be balanced with the recording media (film or digital) in order for the desired effect to be achieved.

Color temperature is measured on a scale known as the Kelvin scale, which is shown in the table opposite.

BELOW
It isn't always desirable to neutralize color casts. This sunset scene has been enhanced using a filter to deepen the orange cast caused by the color temperature of the light.

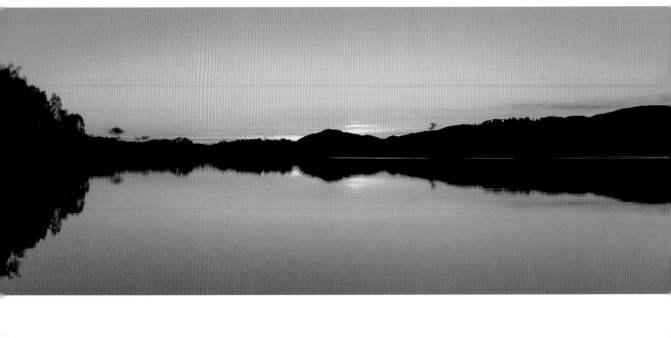

THE KELVIN SCALE

Light source	Color temperature (degrees Kelvin)
Dark shaded area	8,000
Light shaded area	7,100
Sunlight on an overcast (cloudy) day	6,000
Sunlight (at midday in summer)	5,400
Electronic flash (direct)	5,300
Daylight photoflood	4,800–5,000
Sunlight (during early morning/late afternoon in summer)	4,300
Sunlight (one hour after dawn)	3,500
Cool white fluorescent	3,400
Tungsten photographic lights	3,200
100W tungsten lightbulb	2,900
40W tungsten lightbulb	2,500
Sunlight (sunrise and sunset)	2,000
Candle flame	1,900

Using optical filters to manage color temperature

Having covered how WB can be used to correct or enhance color casts caused by changes in the color temperature of light, it is (hopefully) far easier to visualize how optical filters may achieve the same result with either film or digital cameras. In the case of digital, some care must be given to correctly setting WB so that the effects of any optical filter aren't corrected by the camera.

Optical filters that manage color temperature are known as color balancing filters. They come in two guises: color temperature correction (CT) filters and color conversion filters. They are blue or amber and vary in strength. The difference between the two is the amount they shift color temperature—color conversion filters provide a much greater shift than CT filters.

Technically, the purpose of CT and color conversion filters is the same as that of the WB control on a digital camera. CT filters are typically used to correct small shifts in color temperature between 400 and 650K. Greater shifts, such as when photographing under tungsten lighting using daylight-balanced film, are better managed using color conversion filters.

LEFT
Color balancing filters are blue or amber and come in different strengths.

COLOR TEMPERATURE (CT) FILTERS

CT filters are known as 81 series (amber) and 82 series (blue) filters. 81 series CT filters manage color temperature shifts between -100 and -650K. 82 series filters are restricted to shifts of between 100 and 400K. For example, imagine you are photographing an outdoor portrait at around midday on a cloudy day using daylight-balanced film. The film will produce a neutral light when the color temperature is 5,400K, but the cloud cover will make the actual color temperature around 6,000K, a shift of +600K, which will result in a mild blue color cast. To compensate you would need to reduce the color temperature by 600K to get back to the value that the film is balanced (5,400K). Looking at the table below, this can be achieved by using an 81C amber filter, which has a shift value of -400K.

In terms of strength, an 81 filter is the weakest, and its effect is so minimal that it is often hard to notice. The most commonly used of the 81 series are the 81A, 81B, and 81C filters. An 81A filter will add a very mild, but noticeably warm, color cast or correct a slight blue cast. An 81B filter is probably the most commonly used, either to enhance landscape images or correct blue from overcast weather or in areas of dense green foliage, such as forests and woodlands. 81D and 81EF filters have a stronger effect and are useful for correcting blue casts in areas of dense shadow. In terms of enhancement, an 81C amber filter is probably as strong as I would use in outdoor photography, unless I was attempting a particularly unusual effect.

The 82 series of filters provides compensation for unwanted mild warm color casts. For example, electronic flash has a color temperature 100K less than the value for daylight-balanced film. Referring to the table below, the resulting cast can be removed by applying an 82 filter, which shifts +100K. As another example, in a studio the color temperature of a daylight photoflood lighting unit, which has a color temperature around 400–600K below that of daylight-balanced film, can be compensated for using an 82C filter (+400).

TOP
Warming filters are used to reduce blue color casts or enhance red color casts.

ABOVE
Cooling filters are used to reduce red color casts or enhance blue color casts.

COLOR TEMPERATURE SHIFTS AND ABSORPTION FACTORS FOR CT FILTERS		
Filter	Color temperature shift (Kelvin)	Light absorption factor (Stops)
81	-100	+1/3
81A	-200	+1/3
81B	-300	+1/3
81C	-400	+1/3
81D	-500	+2/3
81EF	-650	+2/3
82	+100	+1/3
82A	+200	+1/3
82B	+300	+1/3
82C	+400	+1/3

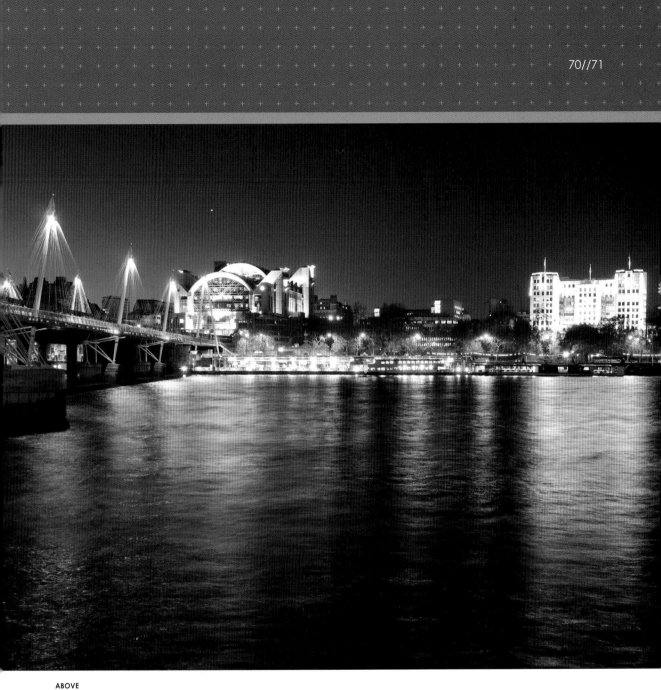

ABOVE
A blue CT filter has
been used to accurately
balance the light in this
night scene.

Color conversion filters are similar to CT filters, except they produce a greater shift in color temperature, as shown in the table opposite.

You may notice that compared to the 81 and 82 series filters, the figures for the 85 and 80 series filters appear backwards. For example, where an 81C filter produces the greatest shift in the 81 series range, the strongest 80 series filter is the 80A. Even more confusing, the 85 amber filter produces a shift value that falls between the 85B and 85C variants in the series. However confusing it may be, these apparent anomalies are simply something you have to get used to.

In practical terms, color conversion filters are typically used to balance artificial light sources when using daylight-balanced film. For example, tungsten photographic lights have a color temperature value of 3,200K, which equates to a Kelvin value of 2,200 below that of daylight-balanced film. Without a compensating filter, this would produce a very strong orange color cast. By applying an 80A (+2,300K) or 80B (+2,100K) color conversion filter, this cast would all but disappear.

Amber (85 series) color conversion filters have less of a technical use and are more likely to be used creatively. They can be applied to balance daylight with tungsten-balanced film, but in reality the likelihood of using tungsten-balanced film outdoors is minimal. However, a muted sunset, for example, would be greatly enhanced by an 85 series filter, much more so than using the milder 81 series of CT filters.

TEMPERATURE SHIFTS AND ABSORPTION FACTORS FOR COLOR CONVERSION FILTERS		
Filter	Color temperature shift (Kelvin)	Light absorption factor (Stops)
85	-2,100	+0.6
85B	-2,300	+0.6
85C	-1,700	+0.3
80A	+2,300	+2
80B	+2,100	+1.66
80C	+1,700	+1
80D	+1,300	+0.6

BELOW
Using an 85 color conversion filter has enhanced the warm glow of sunset in this image.

RIGHT
For precise color balance it is sometimes necessary to use a combination of CT and color conversion filters.

Combining CT and color conversion filters

CT and color conversion filters can be used together in order to fine-tune compensating shifts of color temperature. For instance, in the previous example, photographing under tungsten photographic lights using daylight-balanced film resulted in a difference of 2,200K, and of the solutions provided, neither filter gave an exact compensation value—the 80A filter being 100K more (2,300K) and the 80B filter 100K less (2,100K). To produce an exact compensation value you would need to use a combination of filters—in this example, a combination of 80B + 82 filters, or 80A + 81 filters.

The table below shows the filter or combination of filters needed to balance a light source when using daylight-balanced film.

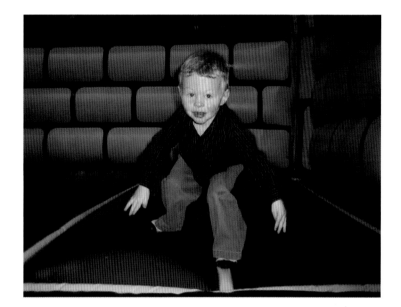

TECHNICAL FILTERS		
Light source (degrees Kelvin)	Color temperature	Required filter(s)
Dark shaded area	8,000	85B + 81B
Light shaded area	7,100	85C
Sunlight on an overcast (cloudy) day	6,000	81D or 81EF
Sunlight (at midday in summer)	5,400	None
Electronic flash (direct)	5,300	82
Daylight photoflood	4,800–5,000	82C + 82A (or 82C)
Sunlight (during early morning/late afternoon in summer)	4,300	80D + 81A
Sunlight (one hour after dawn)	3,500	80C + 82A
Cool white fluorescent	3,400	80C + 82B
Tungsten photographic lights	3,200	80B + 82
100W tungsten lightbulb	2,900	80A + 82A
40W tungsten lightbulb	2,500	80A + 82C + 82A
Sunlight (sunrise and sunset)	2,000	80C + 80C
Candle flame	1,900	80B + 80D + 82

A

B

BLUE FILTERS

I am often asked when it is appropriate to use blue filters. Technically, as well as correcting the warm color cast from some forms of artificial light, they can also be used in outdoor photography. One example would be when photographing architecture in the early morning or late afternoon sunlight, which tends to create a warm color cast that may be non-conducive to capturing an accurate color balance. Similarly, snow and ice, which are naturally cold and therefore we psychologically expect them to appear blue, may benefit from an added blue filter when photographed in warm lighting conditions. Outdoor portraiture is another area of photography where a more natural-looking color balance is preferable to overly warm tones.

USING CC FILTERS WITH DIGITAL CAMERAS

When using optical color conversion filters with a digital camera, be sure to switch WB to a setting other than AWB. In AWB mode, the camera will automatically correct for the effect of the filter, practically rendering it obsolete. For most photographic applications, the best WB setting to use is Daylight, which mimics daylight-balanced film, making the effects of any optical color conversion filter more easily envisaged.

FILM CHOICE

Film is typically balanced for either daylight (c. 5,400K) or tungsten light (c. 3,000K), and it is important to select the right film for the conditions under which you are working. Daylight film is balanced for the neutral light produced at around midday on a sunny day. When used under different lighting conditions, such as at sunrise or under artificial lighting, color casts will result unless an appropriate filter is applied. Similarly, tungsten film is balanced for the neutral light produced by a tungsten bulb. Again, color casts will result if tungsten-balanced film is used under different lighting conditions.

A

B

REFLECTION AND ABSORPTION FACTORS

Placing a colored filter in front of a lens is likely to affect exposure because the filter both reflects and absorbs some of the light passing through it. If you use the camera's built-in TTL meter then this light loss will be accounted for. However, if a non-TTL meter, such as a handheld meter, is used for assessing exposure values, this must be manually accounted for.

One method of calculating reflection and absorption factors is to hold the relevant filter in front of the light meter while taking the meter reading, then applying exposure compensation in AE mode, or switching the camera to manual exposure mode and setting both shutter speed and lens aperture manually, having taken into account the level of light loss. Alternatively, for each filter covered in this book, I have tried to provide general information on the level of light loss, quoted in stops.

FAR LEFT
The warm color cast in image A makes the stone monument appear somewhat unnatural. Using a blue filter in image B neutralized the color cast, resulting in a more natural-looking image.

ABOVE
Some subjects, such as snow and ice, look more natural with a blue color cast. Compared with image A, image B benefits from the added blue filter to heighten the sense of a cold temperature.

The ways in which optical color correction filters can be used creatively are much the same as the ways WB can be applied to enhance or completely alter the appearance of color, as discussed in Section 4. For example, in the section on WB I describe photographing a dull sky using the Fluorescent WB setting (see page 154). Subsequently, I have reverted to doing much of this type of photography when using a large-format film camera. I wanted to recreate the brilliant blues that I achieved with the digital camera set to Fluorescent WB and, in order to achieve this, used an 82B blue filter, which produced much the same results.

Another example is illustrated by the image shown on the right. I shot this while hiking in the Tatra Mountains in Slovakia. I used a long telephoto lens to compress the space between the mountains, creating a layering impression. The conditions weren't ideal for photography, as the sky was a very dull light gray. To enhance the composition, I added an 82C blue filter, which completely changed the atmosphere and feel of the photograph.

ABOVE
Using a strong blue filter in this image greatly transformed what was once a dull, gray sky.

RIGHT
The intense blue sky in this night scene is a result of using a blue color conversion filter.

With many of these creative techniques there is a lot to be said for experimenting, trying out new ideas, and occasionally breaking the rules. The fact that you can immediately see the effects of changes to settings such as WB is one of the great advantages of digital cameras, whereas with film cameras there is always the need to wait until the film is processed before you can assess the impact of your actions.

TYPES OF COLOR CORRECTION FILTERS

Whenever I photograph wildlife using a film camera, I nearly always have an 81A amber screw-in filter attached to the lens. I no longer practice this technique with my digital cameras, but instead use the WB control to replicate the effect of the warming filter. In landscape photography I tend to use slot-in filters whenever I am using color correction filters, primarily because I will already have a filter holder attached to the camera and it is therefore easier to simply slot in a warming or cooling filter than it is to detach the holder, attach a screw-in filter, then reattach the filter holder.

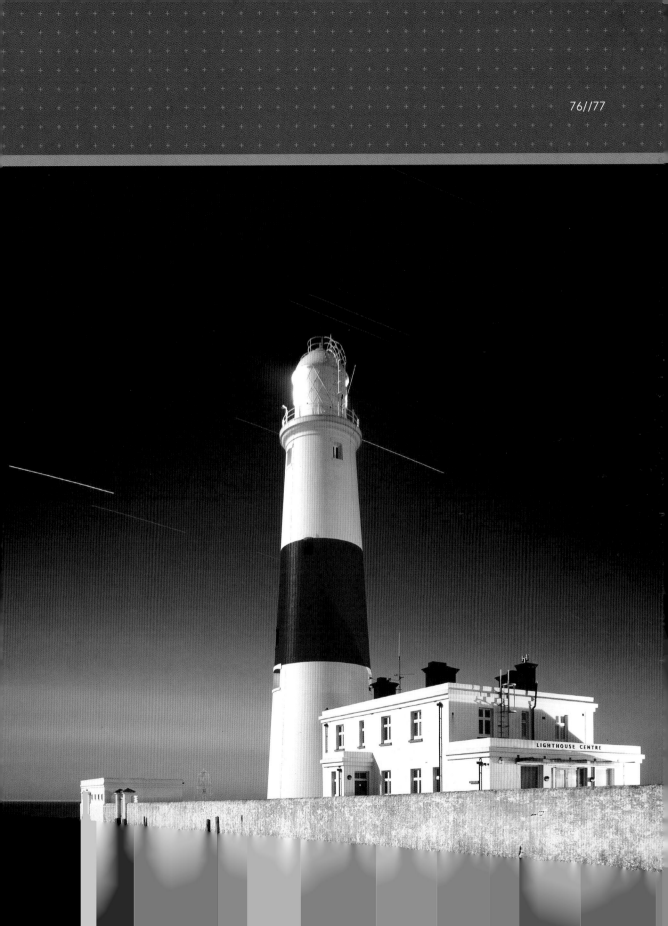

So far I have talked about the warm (red/orange) and cool (blue) color casts that are caused by variations in the color temperature of light, relative to the recording material. However, other factors can also cause color casts to occur that are less easily compensated for. For example, fluorescent lighting produces inconsistent green casts, caused by the fluorescers in the tube glowing at different wavelengths. Mercury vapor lights, such as street lights, cause light to reflect off a colored surface, and variations in climate can also produce different colored casts on top of those caused by shifts in color temperature. Additionally, when some films are exposed for long periods they are affected by color shifts that also result in color casts, due to the law of reciprocity failure.

A digital or optical solution can be used to combat these diferent color casts. Digitally, as with WB, settings in the camera can be adjusted—in this case Hue. For example, applying an amount of magenta hue will compensate for and remove the green color cast from fluorescent lighting. The difficulty is knowing exactly how much to adjust the Hue setting, as there are no preset values. Similarly, if a digital image is captured

in the RAW file mode, color compensation varying between green and magenta can be applied in-computer during the RAW conversion stage of image processing. This is done by adjusting the Tint slider by an appropriate amount, which appears below the Temperature slider in the WB adjustment control. Making color corrections at the processing stage is far easier than in-camera, as it is possible to make a visual assessment of the amount of adjustment needed. The limitation with these two digital solutions is that you are restricted to shifts between green and magenta, which may be insufficient, and of course, they are of no use when shooting film.

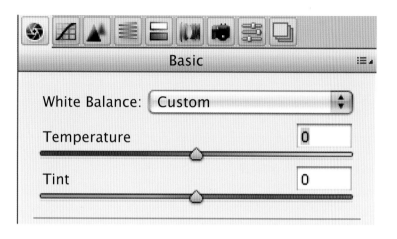

ABOVE
RAW files can be adjusted for green/magenta color compensation during the RAW conversion process.

RIGHT
The color casts caused by the mix of natural and artificial light has been compensated for during the RAW conversion stage of image processing.

COLOR CAST COMPENSATION

Compensating for color casts is much easier to apply in-computer. See pages 136–145 for tips on how to remove or lessen the effects of color casts using Photoshop.

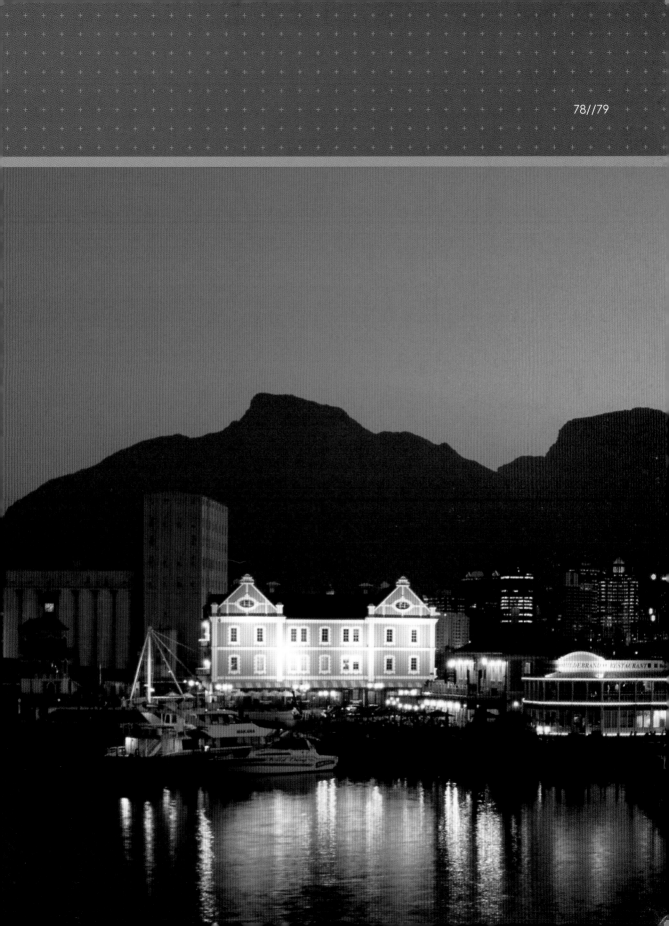

For precise in-camera correction, and when film is used as the recording media, color compensating filters offer an optical solution to color balancing beyond warm and cool casts. Color compensating filters are available in varying densities (typically 5, 10, 15, 20, 30, 40, and 50) of yellow, magenta, cyan, red, green, and blue.

To understand fully how color compensating filters work, it is first necessary to appreciate how color is formed. There are six color primaries in the visible spectrum—three additive primaries and three subtractive primaries, from which the millions of colors that we see and recognize are produced. The additive primaries are red, green, and blue. Adding an equal mix of red and green creates yellow; green and blue creates cyan; and red and blue creates magenta. An equal mix of all three additive primaries creates white.

The subtractive primaries are yellow, cyan, and magenta. Subtracting yellow from cyan and magenta creates blue; subtracting cyan from yellow and magenta creates red; and subtracting magenta from yellow and cyan creates green. Take away all three subtractive primaries and you are left with black.

ABOVE LEFT
The additive primaries consist of red, green, and blue (RGB).

ABOVE
The subtractive primaries consist of cyan, magenta, and yellow (CMY).

LEFT
A red filter will pass red light waves and block blue and green. A magenta filter will pass both blue and red light waves, because magenta is formed from mixing equal amounts of red and blue.

COLORS THAT COLOR COMPENSATING FILTERS PASS AND BLOCK		
Filter color	**Color passed**	**Colors blocked**
Red	Red	Green and blue
Green	Green	Red and blue
Blue	Blue	Red and green
Yellow	Yellow, red, and green	Blue
Cyan	Cyan, green, and blue	Yellow
Magenta	Magenta, red, and blue	Green

Color compensating filters work by allowing only their own color to pass through and blocking other colors. The reason why it is necessary to understand how color is made is so that you know which colors any given color compensating filter will pass and which they will block. For example, a red filter will allow red light to pass through and will block blue and green light. However, magenta is formed from a mixture of red and blue light, so a magenta filter will allow these two colors to pass through, but will block green light.

In practice, then, if fluorescent lighting creates a green color cast on daylight-balanced film, then a magenta color compensating filter, which blocks green light, will remove it. If light reflecting from a yellow surface creates a yellow cast, a cyan color compensating filter, which blocks yellow light, will produce a color-balanced image, and so on.

With the notable exception of fluorescent lighting, in reality the level of color accuracy created by color compensating filters is unnecessary for most enthusiast photographers, particularly shooting digitally because color casts can be removed and color balance fine-tuned during image processing. Professionally, only commercial and industrial photographers who need precise color balance when photographing interiors, food, or products under available light will need to use color compensating filters.

COMBINING COLOR BALANCING FILTERS

When photographing outdoors I use a purpose-made 81 series + color compensating combination filter (a mix of 81B + 20CC green) when photographing in dense woodland. The 81B filter removes the blue color cast caused by the shadowy environment, while the green color compensating filter intensifies the color of the green foliage.

A

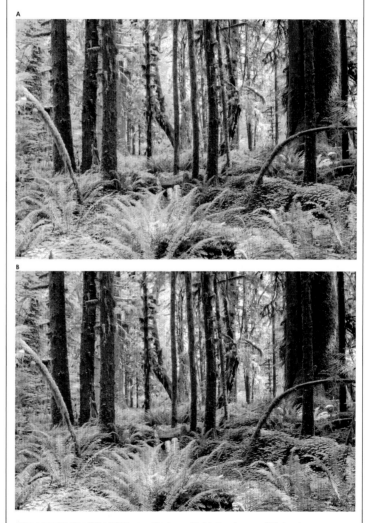

B

Using a combination 81B + 20CC green filter has added to the vibrancy of this forest scene (image A), compared with the non-filtered image (image B).

EXPOSURE COMPENSATION FOR COLOR COMPENSATING FILTERS

When using a non-TTL light meter, the following exposure compensations should be applied with color compensating filters.

Filter	CC5	CC10	CC15	CC20	CC30	CC40	CC50
Red	+0.3	+0.3	+0.3	+0.3	+0.6	+0.6	+1
Green	+0.3	+0.3	+0.3	+0.3	+0.6	+0.6	+1
Blue	+0.3	+0.3	+0.3	+0.6	+0.6	+1	+1.3
Yellow	Nil	Nil	+0.3	+0.3	+0.3	+0.3	+0.6
Cyan	+0.3	+0.3	+0.3	+0.3	+0.6	+0.6	+1.6
Magenta	+0.3	+0.3	+0.3	+0.3	+0.6	+0.6	+0.6

Color temperature meters

For precise color balancing it is recommended that you use a CT meter to accurately measure temperature variations. These devices are similar in appearance to handheld light meters and are used in much the same way as when taking an incident light reading (as opposed to a reflected light reading).

Essentially, CT meters consist of three cells covered by a diffuser. The cells separately measure levels of red, green, and blue light, while the diffuser integrates the light reaching the cells. The measurements are then analyzed by the meter to provide both the exact color temperature of the environment in which you are shooting, and the recommended filters to correct the color balance.

CT meters are not cheap and are largely used by professional commercial photographers who need very precise color reproduction.

LEFT
Color temperature meters can be used to accurately measure the color temperature of a scene.

COMBINING FILTERS

Color compensating filters can be used in combination to create stronger densities. For example, adding a color compensating15 filter to a color compensating 40 filter will create a 55 density color compensating filter.

RIGHT
For precise color balancing, professional photographers use color compensating filters and color temperature meters when photographing food and products under available light.

Imagine photographing a building interior where the scene is lit by both natural and artificial light. The problem this creates is that you have two different levels of color temperature—one for daylight and one for artificial light. If you filter for one, then you will adversely affect the other.

For example, if you add a blue filter to balance the warm tones of a tungsten light source, natural light will show a distinct blue cast. Conversely, if you use no filter, effectively balancing the natural light in the scene, the tungsten light will create a strong orange color cast in the parts of the scene it is illuminating.

In this instance, the best solution is often to use a digital camera to capture the image (or digitally scan a film image) and then use selective color correction techniques in-computer to fix parts of the scene that are affected by color casts. A word of caution, however—it takes a very skilled photofinisher to complete this task and produce a natural-looking result!

Failing this, you can compromise by color balancing for the principal light source and hope that the effect on the secondary light source is negligible. If shooting film, then using negative film as opposed to slide (positive) film will give you more options to color balance at the processing stage.

RECIPROCITY LAW FAILURE

Reciprocity law failure is only relevant to photographic film. When you expose film for long periods, typically more than one second, the reciprocal relationship affecting exposure breaks down, with the result that longer exposures are required. Additionally, when reciprocity law fails, some film types are affected by color shifts that must be corrected. Most manufacturers provide the relevant information for balancing color shifts on their websites. The table below provides a synopsis of information for commonly used films.

FLB AND FLD FILTERS

When using film under fluorescent lighting conditions, an alternative to color compensating filters is the FL series filter, available as FLB for use with tungsten-balanced film and FLD for use with daylight-balanced film.

DIGITAL PHOTOGRAPHY

Given the complexity and effort required to accurately correct color shifts caused by variances in light when shooting film, digital capture can be seen as a distinct advantage over film.

COLOR COMPENSATION FILTERS FOR RECIPROCITY FAILURE

Film type	1 sec	10 sec	90 sec
Kodachrome 64	CC10 red	NR	NR
Kodak Elite Chrome (100/200/400 ISO)	None	None	CC75 yellow
Kodak Ektachrome (E100/E100SW)	None	None	CC75 yellow
Fuji Velvia	None	CC10 magenta	NR
Fuji Sensia II 100	None	None	CC25 red
Fuji Provia 100F	None	None	CC25 red
Fuji Astia	None	None	None
Agfachrome RSXII 100	None	CC5 blue	CC10 blue

A

LEFT AND BELOW
Balancing a scene
with mixed lighting
is challenging. Here
I opted for color
balancing the
tungsten lighting,
resulting in a more
natural, cooler scene
(image B) compared
with image A, which
has been color
balanced for daylight
entering through
the windows.

B

Over the years I have read several books and articles on the theory of light, polarization, and polarizing filters, and I have to admit to being largely none the wiser for it. This is partly due to the many theories appearing to contradict one another. In the end, I concluded that knowing what a polarizing filter actually does is far more important than understanding how and why they work.

The practical applications of polarizing filters

In photography, polarizing filters can reduce or eliminate glare and reflections from non-metallic surfaces, deepen blue skies, and saturate colors. They are perhaps, next to UV filters, the most commonly used of all the filters, and can create dramatic effects. However, they should be used with caution, as their effects can often appear unnatural and overpowering.

Glare and reflections

Imagine taking a photograph of a driver through a car windshield. The likely outcome will be that the driver is obscured by the reflections from the windshield, as illustrated by the image below left. The reason this happens is all down to a man named Brewster, as I shall attempt to explain below.

When light hits a shiny, non-metallic surface such as glass, water, or a gloss sheen (such as that found on some foliage), most of it passes through, illuminating the subject on the other side and reflecting back toward, in this case, the camera. However, light that hits the shiny surface at a specific angle, known as Brewster's Angle, reflects directly off it without passing through, becoming polarized. This results in two types of reflected light reaching the camera—in this example, non-polarized light from the car driver and polarized light from the windshield, which, to all intents and purposes, results in two images being recorded by the camera simultaneously—one of the driver and one of the reflections from the windshield, acting like a multiple exposure.

Continuing with the example of the car driver, a polarizing filter placed in front of the lens, positioned at an angle exactly matching Brewster's Angle, will entirely eliminate the polarized light reflecting off the surface of the windshield by blocking it, and at the same time allowing the non-polarized light reflecting off the driver to pass through without interference (see image below right).

BELOW
Polarizing filters are one of the most used filter accessories in photography.

ABOVE
Without a polarizing filter, glare reflecting from the glass windshield obscures the driver.

RIGHT
With a polarizer in place, polarized light reflecting off the windshield is blocked, resulting in a cleaner image.

A

The same theory applies to water. Reflections on the surface of water can be eliminated or reduced using a polarizing filter, enabling one to see and photograph whatever is below the surface. Of course, if you are specifically attempting to photograph surface reflections, then avoid using a polarizer altogether.

LEFT AND BELOW
In image B,
a polarizing
filter removes
the reflections of the
surface of the water
seen in image A.

B

A polarizing filter will also reduce reflections found on shiny or wet foliage, such as leaves. For example, as light strikes the surface of a drop of water, some light passes straight through and is either absorbed by the leaf (giving it color) or reflected back toward the camera. However, the light that strikes the surface of the drop at an angle equal to Brewster's Angle for water (53 degrees) is reflected directly back in a polarized state toward the camera. By applying a polarizing filter at the correct angle of rotation (see page 90), this polarized light can be blocked, enhancing the unblocked, non-polarized light reflecting off the leaf to pass through to the film or sensor.

Glare caused by polarized light will make colors appear dull, particularly when the weather is overcast (due to increased scattering of light). A polarizing filter will reduce the effects of glare, increasing color saturation spectacularly and producing crisper images.

Blue skies

The other common use for polarizing filters is to deepen the color of blue skies. The air contains billions of tiny translucent particles and they can cause some of the light rays striking them to become polarized. When a polarizing filter is used, this polarized light is blocked, enabling the true undiluted color of the sky to shine through.

One side effect of this is that solid objects set against the sky stand out more, such as white clouds set against a dark sky. This is due, in part, to an increase in contrast, but also because non-transparent objects (clouds, buildings, etc.) produce no polarized light, and are therefore unaffected by polarizing filters.

Photographing blue skies is an area where polarizers must be used with a certain degree of caution, so as to not overdo the effect. Skies that appear too dark or deep in color will look very unnatural, simply because this

is how we see the sky. At high altitudes, using a polarizer can cause a blue sky to appear black. Positioning the filter at a 45-degree angle toward the sun, rather than the normally advised 90 degrees, will produce a more natural effect. Care should also be taken when using a wide-angle lens to photograph a scene that includes a blue sky.

ABOVE
Polarizing filters have deepened the color of the blue sky in this image.

TOP RIGHT AND RIGHT
Because clouds are non-transparent they are unaffected by polarizing filters. When a polarizer is used, clouds will stand out more (image B) than when no polarizer is used (image A).

FAR RIGHT
Using a polarizing filter to shoot this scene has resulted in an unnaturally deep blue sky.

A

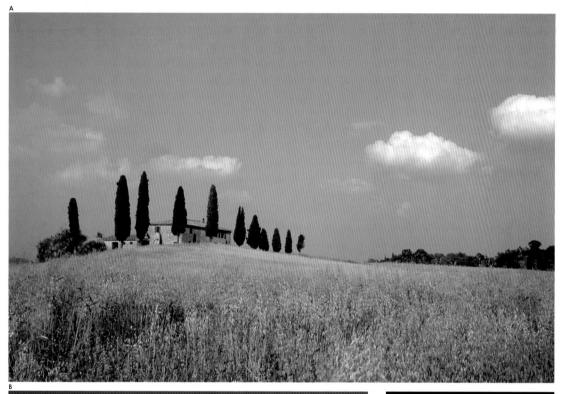

B

Choosing a polarizing filter

Polarizing filters come in two varieties: linear and circular. Which one you choose will largely depend on the camera you are using. If you have an automatic camera with TTL metering and you rely on the camera's metering system when assessing exposures, then you will need a circular polarizer. If you calculate and set exposure manually or use a camera with a non-TTL type meter, then a linear polarizer will suffice. If you attempt to use a linear polarizer with a TTL type meter, then exposure errors can occur.

Like true ND filters, polarizers should be neutral and have no effect on color rendering. However, not all polarizers are truly neutral, particularly some of the less expensive products, and are liable to introduce a cool blue color cast. To compensate for this color cast, use a combination warm polarizer, such as those made by Singh-Ray and Tiffen, or simply combine a polarizing filter with an 81A or 81B amber filter.

Using polarizing filters

Because physics governs the technology behind polarizing filters, physics can be employed to put them to use with the utmost accuracy. For example, we know that Brewster's Angle for water is 53 degrees, so if you align a polarizing filter at 53 degrees it will work at its optimum level. But that's just a theory—after all, how many of us are likely to measure a camera angle to that level of precision? In reality, knowledge of polarizing filters is best achieved through a series of trial and error.

For best results when using a camera with a TTL viewfinder, the camera with a polarizer attached to the front of the lens should be positioned at 90 degrees to the sun. A simple method for checking the camera's position is to point your index finger at the object being photographed and then stick out your thumb so it is at a right angle to your extended index finger and parallel to the ground. Your thumb should now be pointing at the sun. (If the sun is on your left, use your right hand, and vice versa.)

Looking through the viewfinder, rotate the polarizing filter through 360 degrees in a clockwise direction (this is important, as turning it counterclockwise can cause the filter or adapter ring to unscrew and fall off), taking note of how the scene changes. At full polarization, the surface reflecting polarized light (e.g. the sky) will be at its darkest. As you rotate the filter to reduce polarization the reflected surface will lighten. Once you have assessed the scene, set the filter to a position that gives the most aesthetically pleasing result.

A

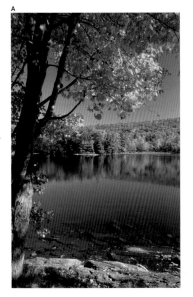

B

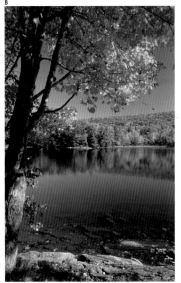

LEFT
Compare these two images. A warm polarizer (a combination of a polarizer and an 81 series filter) adds a warm color cast to image A. In this example, image B has benefited from a warm color cast, which has added a sense of depth.

ABOVE
Circular polarizing filters are specifically designed for use with automatic SLR cameras.

USING POLARIZERS WITH VIEW CAMERAS

A view camera is effectively the same as an SLR camera, in that what you see on the viewing screen is being passed through the lens. However, the brightness of the image on a viewing screen in a view camera is typically much darker than that visible via a viewfinder of an SLR, and can be so dark that it makes composing and focusing very difficult. Polarizing filters reduce the level of light passed through the lens by 2 stops, making viewing the image on the screen almost impossible, even with the lens set to its maximum aperture. Therefore, when using a view camera, it may be easier to use the technique described for non-SLR cameras (see page 92) when assessing the appropriate position for the filter.

USING POLARIZERS WITH POLYESTER FILTERS

When using a polarizing filter in conjunction with one or multiple polyester filters, the polarizer must be placed in front of the polyester filter for it to function correctly.

When using a polarizing filter to specifically reduce or eliminate reflections, the angle between the reflective surface and the lens axis needs to be around 30 degrees. However, this may result in a less than desirable composition, in which case you may have to make a compromise between the extent to which the offending reflections are reduced and your ideal composition.

It is also believed that polarizers only work in bright sunny weather. This may be true if you are attempting to produce an image with a deep blue sky, but polarizers may also be effective at removing reflections in severe weather, and at any time during the day.

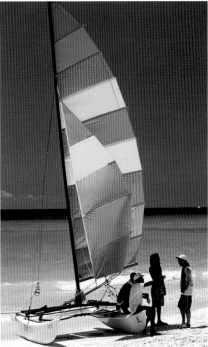

FAR LEFT
Here is an example of using a polarizing filter with a 5 × 4 view camera.

LEFT
Sticking to the 30-degree rule has compromised the composition of this image, as the top of the catamaran has been cut off.

Metering and exposure

Polarizing filters reduce the amount of light passing through them by 2 stops. When a circular polarizing filter is used with a camera that has TTL metering, the camera's meter will automatically compensate for this loss of light and there is no need for manual intervention—you would simply set your exposure in the normal way.

When using a linear polarizer with a TTL camera, first take a meter reading with the filter unattached and set an appropriate combination of lens aperture and shutter speed (and ISO, if relevant). After attaching the polarizer you need to increase the exposure by 2 stops to compensate for the filter. You can do this either by setting the camera's AE compensation function to +2 stops (if it has one), or by manually setting a slower shutter speed, wider aperture, or higher ISO (in digital photography).

For example, if the meter reading taken without the filter attached gives an exposure setting of 1/250 sec at f/11, then the compensated exposure would be either 1/60 sec at f/11, 1/250 sec at f/5.6, or 1/125 sec at f/8—all of which equates to a 2-stop increase in exposure. The process is the same when setting exposure on a manual camera and when using a handheld light meter to assess an exposure value.

USING A POLARIZER AS AN ND FILTER

Because polarizing filters reduce the amount of light passing through them by 2 stops, and because they have no effect on the color of light being passed through, they can be used as an effective 2-stop ND filter (see page 66). However, be aware that they will continue to affect polarized light in the normal way, and therefore may alter the appearance of any transparent objects in the scene.

Using polarizers with non-SLR cameras

The advantage of SLR cameras is that you can see the effect of a polarizer directly through the viewfinder, meaning that the filter can be attached to the lens, rotated to the appropriate position, and gauged via the viewfinder before the picture is taken. However, if you are using a non-SLR camera, such as a rangefinder camera or an old twin lens reflex camera, then accurately positioning a polarizer becomes more difficult because its effects cannot be determined via the finder. And, as mentioned earlier, this may also be the case with view cameras if the image on the viewing screen is too dark to assess accurately.

In all of these cases a more arbitrary technique must be employed. If using a slot-in filter system, one technique is to hold the polarizer in your hand just above the lens and, while looking through the filter, rotate it to the relevant position. Then, making sure not to turn it further, smoothly slot it into the holder on the lens and take the picture. A similar method can be used without a filter holder, instead using two blobs of Blu-Tack, for example, to secure the filter to the front of the lens barrel. In either case, the important thing to remember is to keep the polarizer at the correct rotation.

A slightly more accurate method can be used when employing a screw-in filter when two identical filters are used together. First, matching index marks must be etched onto each filter. A sensible system would be mirroring the position of the numbers on a clock. One filter is then attached to the lens. The photographer looks through the matching filter and rotates it to the relevant position. Next, referring to the index marks, the filter on the camera can be rotated to the same position.

Using polarizers with wide-angle lenses

When photographing a scene with a blue sky, maximum polarization occurs when the filter is at 90 degrees to the sun. If you were to use a lens with a 1-degree angle of view then almost the whole area of sky would be at maximum polarization, resulting in an even tone across the sky visible through the lens. However, there is no such lens, and angle of view can extend to 180 degrees for a fish-eye lens and 65 degrees for a 28mm lens.

The greater the angle of view, the further from 90 degrees the edge of the frame becomes, resulting in uneven polarization that appears as a dark patch of sky in the center of the image, gradually lightening toward the edges. It is a very unnatural and odd-looking effect. The remedy is to move the filter away from the full 90-degree position in the first place, so that the center of the frame isn't fully polarized.

Care should also be taken to ensure that vignetting doesn't occur when using ultra wide-angle lenses, such as those with a focal length of 20mm or less. Many of the manufacturers of screw-in filters have produced special slim-line polarizers that are designed for use with wide-angle lenses up to 17mm. When using slot-in filters, one solution is to use the Blu-Tack technique, described previously.

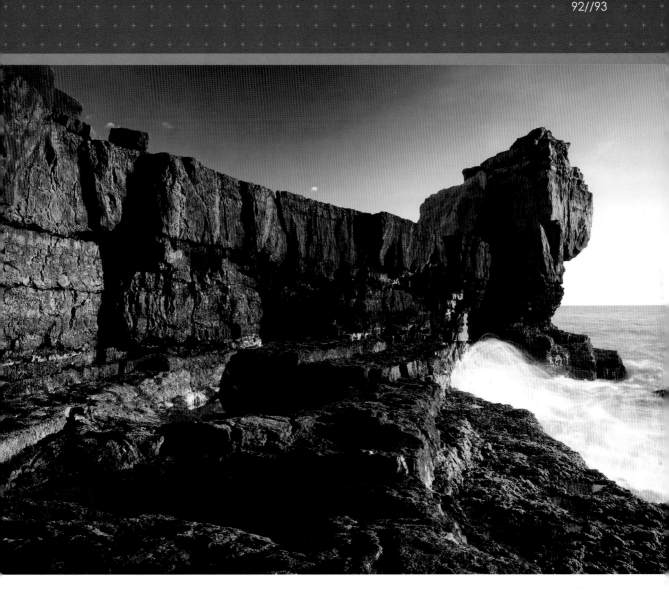

ABOVE LEFT
Utilizing index markers on the filter rim can make using polarizers with non-reflex cameras much more accurate.

ABOVE
Using polarizers with wide-angle lenses can result in uneven levels of polarization, as seen in the dark circle of blue sky at the top center of this image.

All of the filters discussed so far, with the exception of color balancing filters, can be applied in black-and-white photography. There are six main colored filters used in black-and-white photography—yellow, yellow/green, green, orange, red, and blue. As with all color filters, they work by allowing certain light waves to pass through, while blocking others. In this case, colored filters lighten their own color and darken their complementary color. For example, a red filter will lighten red tones and darken greens and a blue filter will lighten blues and darken orange tones (see the color wheel diagram below). The result is an ability to manipulate tonal balance and contrast at the point of capture that impacts the mood of the photograph.

For example, examine the four images of the red and green bell peppers, shown opposite. As the two tones are almost identical in terms of shades of gray, in image B it is almost impossible to tell the difference between the two peppers. Image C was photographed using a green filter, and a clear difference is noticeable; the filter has lightened the green pepper and darkened the red pepper (red is the complementary color to green). In image D, a red filter has been used; this time the red pepper has been lightened and the green pepper darkened. This simple example shows what happens to gray tones when colored filters are applied in black-and-white photography.

BELOW
Color relationships: in black-and-white photography, colored filters work by lightening their own color and darkening their complementary color.

PRIMARY

TERTIARY

TERTIARY

SECONDARY

SECONDARY

TERTIARY

TERTIARY

PRIMARY

PRIMARY

TERTIARY

TERTIARY

SECONDARY

A

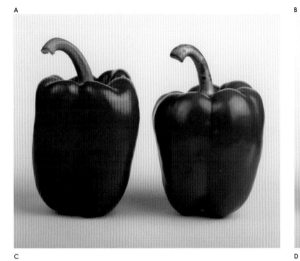

B

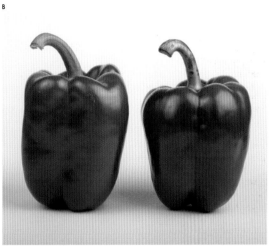

C

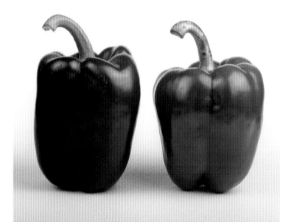

D

ABOVE
Here you can compare the effects of black-and-white filters on a color image (image A). Unfiltered, a red and green bell pepper photographed in black-and-white will produce similar tones (image B). Applying colored filters will alter tonal balance so that, with a green filter the red pepper appears darker (image C), and with a red filter the green pepper appears darker (image D).

A
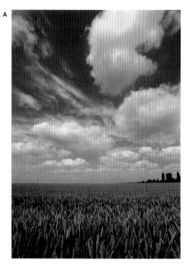

B
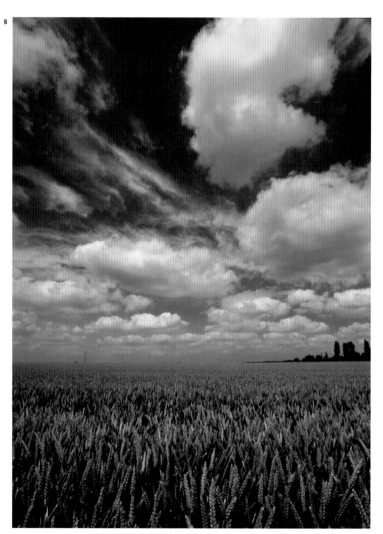

Colored filters also affect levels of contrast, as can be seen in these photographs of a cloudy blue sky. Image A was photographed with no filter and, compared with image B, which has been shot using an orange filter, has far less contrast. This is because in image B the orange filter has darkened the blue sky (blue is the complementary color to orange), extending the tonal range between the dark gray tones of the sky and the very light gray and white tones of the clouds.

This rule isn't as specific as it sounds. For example, a red filter will darken a blue sky even though blue isn't the complementary color of red. Refer to the color wheel, however, and you'll notice that blue is next to red's complementary color (green), and that red is adjacent to the complementary color of blue (orange). So, colored filters have some effect on other color tones but at a reduced level, depending on how far it sits from the primary of the complementary color on the wheel. What this enables you to do is manage the extent to which you manipulate contrast. For a pronounced effect, using a filter that directly matches the primary/complementary chart (e.g. an orange filter to darken a blue sky or a blue filter to lighten a blue sky) will produce the most noticeable effects. For a less dramatic effect, while still altering the tonal balance, choose a filter of a color close to the primary/complementary color in the scene.

ABOVE
Using an orange filter (image B) has increased the contrast between the blue sky and the white clouds, compared to the original, unfiltered image (image A).

THE EFFECTS OF COLORED FILTERS IN BLACK-AND-WHITE PHOTOGRAPHY

Filter	Effect
Yellow (see image A)	Produces the least dramatic effect of all colored filters. Will slightly darken a blue sky and can reduce the effects of haze. A good filter for outdoor portraits.
Yellow/Green (see image B)	Similar to a yellow filter but also lightens green tones, which can increase contrast between a blue sky and green foreground in landscape photography.
Green (see image C)	Lightens green and darkens red tones. Has no effect on skies.
Orange (see image D)	Greatly darkens blues, lightens oranges, and, to a lesser extent, green tones. Will produce a stark effect in landscape photography.
Red (see image E)	Similar to an orange filter, but with an even more pronounced effect on contrast. Useful when a contrast-rich image is desired.
Blue (see image F)	Will lighten blue tones and darken orange, and to a lesser extent, red tones. Is a useful filter for black-and-white outdoor portraiture, as it strengthens skin tones. It is less useful in landscape photography.

The unfiltered image.

A B C D E F

Visualizing the effects of colored filters
The challenge that most photographers face when using colored filters in black-and-white photography is being able to visualize how a scene will look when converted to gray tones. The problem is a very basic one because we see in color. Unfortunately, there is no easy answer and the ability to "see" in black and white is a skill that will improve with experience. It's a matter of practice makes perfect.

There are some exercises that you can practice, however, that may help speed up the process, and this is an area where digital processing can add a great deal of value. For example, take a series of photographs of particularly colorful scenes with your digital camera, such as a funfair, market, or a set of colored pencils or crayons. Upload the images to your computer, and with image-processing software convert the color images to black and white (see pages 166–169 for an example of how to do this in Photoshop). Save the file using a different name to the original and then open the two files next to each other on the screen. Compare the two images and note how different colors are recorded in gray tones.

To see how different colored filters can affect a black-and-white image, follow the steps described on pages 94–95, and using one or more of your sample images compare the original with the filtered image.

Another useful technique when in the field is to carry a Kodak gray card with you and use it to assess tonality by holding it up against the various tones in the scene for comparison. Where most of the tones are similar to those on the gray card, the scene lacks contrast. Where there are numerous tones that are either lighter or darker than the gray card, the scene has more contrast. In a low-contrast scene, in order to increase contrast choose a colored filter that is complementary to the main color in the scene. For example, if you were photographing a landscape scene where you wanted to increase contrast in the blue sky, you might apply an orange filter, orange being the complementary color to blue. This practice mainly relates to film capture; for a detailed description of shooting digitally for black and white, see page 166.

If using a non-TTL light meter to assess exposure values, the exposure compensation factors on the opposite table will apply.

A

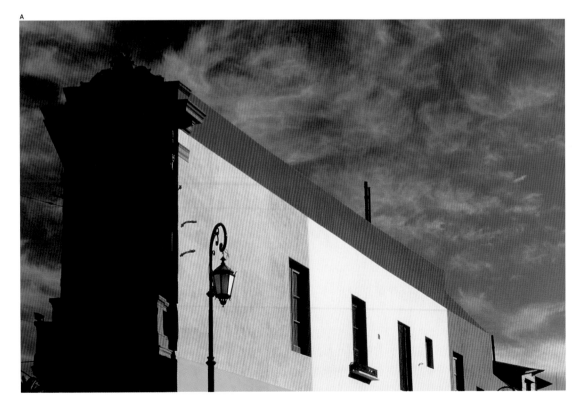

EXPOSURE COMPENSATION FACTORS

Filter	Exposure compensation (stops)
Yellow	+1
Yellow/Green	+2
Green	+2.5
Orange	+2
Red	+3
Blue	+2

HIGH-ALTITUDE PHOTOGRAPHY

Care should be taken when using colored filters for contrast control at high altitudes, where the air is crisp and the light clear, to greatly enhance the effect of filters. Even a yellow filter, which has minimal impact at ground level, can significantly alter contrast. A red filter is likely to render blue tones black.

TYPES OF COLORED FILTERS

If you intend to use colored filters in conjunction with other filter types, such as polarizers or GND filters, then it makes sense to use the slot-in variety. When used entirely in isolation, however, screw-in filters are a suitable alternative.

BELOW LEFT AND BELOW
Photographing a colorful scene (image A) and reproducing it in black and white (image B) will help you learn how to read tonality when in the field.

B

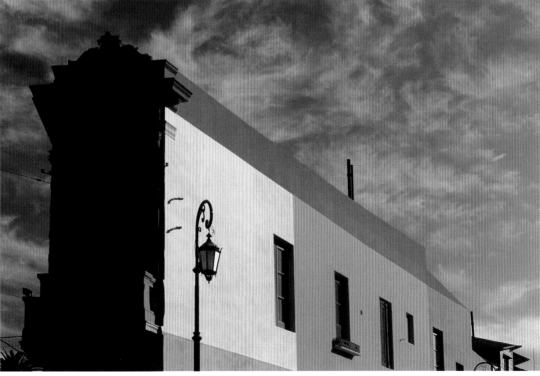

Using graduated colored filters

Graduated colored filters are discussed thoroughly in the next chapter, but I have also included them in this section because in black-and-white photography they can be used in a technical way to manage excessive scene contrast, particularly in landscape photography.

Under normal circumstances, to reduce SDR within camera or film dynamic range, for example to darken a very bright sky, you might use a GND filter, as described on pages 50–53. The benefit of neutral density is that it has no effect on the color of the light it passes—it is neutral and therefore produces no unwanted color casts.

In black-and-white photography, however, color casts are irrelevant because they aren't recorded. Therefore, colored graduated filters can be employed to reduce both SDR and manipulate tonal balance and contrast. For example, we have already seen that an orange filter will darken a blue sky, enhancing contrast between sky and clouds to achieve a more dramatic visual effect (see page 96). Referring to the table on page 99, you will notice that an orange filter absorbs around 2 stops of light. Using a graduated orange filter, then, it is possible to reduce the brightness of the sky by 2 stops to bring it within the dynamic range of the camera or film, and at the same time increase contrast between the sky and clouds without affecting the foreground.

A
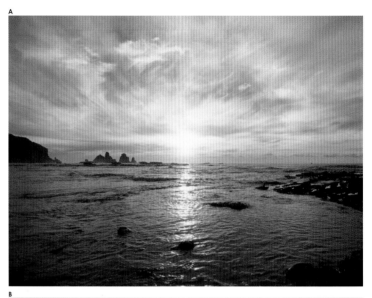

B
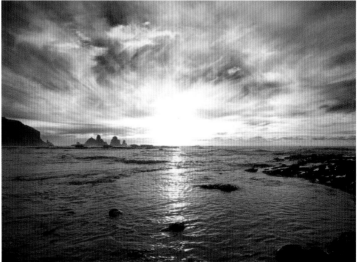

TYPES OF COLORED GRADUATED FILTERS

For the same reason that I recommend slot-in filters for GND filters, I also recommend choosing slot-in colored graduated filters because they make accurate alignment easier to achieve.

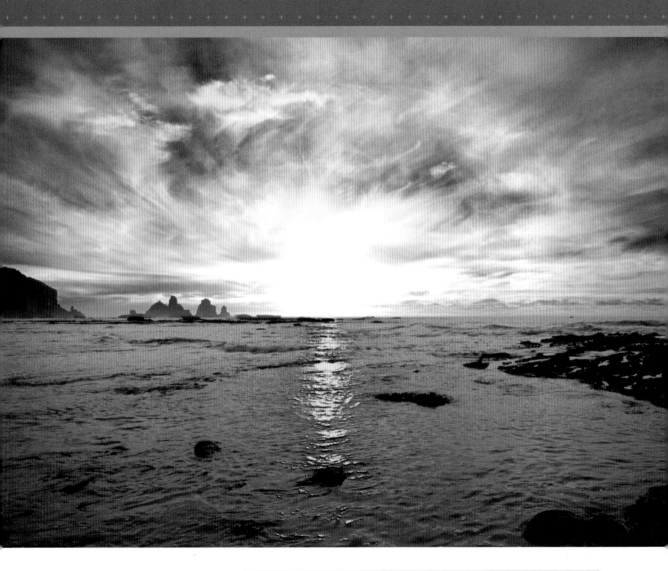

ABOVE LEFT AND LEFT
By applying
a graduated red
filter to the area of
sky, increased contrast
has improved this
image of a seascape
(image B) compared
to the original,
unfiltered image
(image A).

ABOVE
Here a multicolored
filter (top half red,
bottom half blue)
has improved the
image further by
increasing contrast
in both upper and
lower portions
of the scene.

MULTICOLORED FILTERS

You can get even more creative by combining graduated colored filters
and inverting one or the other. For example, you could use an orange
graduated filter to enhance contrast between the sky and clouds and,
by inverting a green filter, lighten green tones in the foreground. Some
photographers even go so far as to have multicolored filters made specially,
where the top half is one color and the bottom half is another color. Lee Filters
offers this custom service.

SECTION 3

CREATIVE AND SPECIAL EFFECTS

CREATIVE FILTERS

Although photographic filters are predominantly employed for technical reasons, there is a selection of filters that provide photographers with more creative opportunities. Creative filters include those that achieve subtle effects, such as softening filters; outlandish effects, such as diffraction and starburst filters; and something in between, such as colored graduated filters. It is fair to say that creative filters are not for everyone—some photographers love them, and others hate them. Used thoughtlessly they can produce some hideous results, but in clever hands and with an eye toward the imaginative, they can add to the art of photography. There are hundreds of creative filters available and I have selected a few to cover in this book; primarily those I believe can be used to enhance a picture rather than alter it beyond all recognition, with perhaps the exception of infrared filters, which I have specifically included because it is a popular style of photography.

OVEREXPOSING BACKLIT SUBJECTS

When photographing backlit subjects using a soft-focus filter, try overexposing the image by around 0.5 stops to create an enhanced ethereal atmosphere.

Soft-focus filters

Soft-focus filters add mood to an image. They can give landscapes a greater sense of atmosphere, romanticize portraits, eradicate skin blemishes and imperfections, and turn an unattractive cityscape into a far more ambient scene that is full of character. They work by blending highlights into shadow areas, which occurs when light passing through a soft-focus filter refracts or bends.

Softening effects are most often used in portrait photography, so positioning your subject against a dark background and lighting the face with a soft light will create a beautiful effect. For landscapes, shooting into the light will add an ethereal glow to the scene when exposing for shadow areas.

Varying lens aperture will alter the effect of a soft-focus filter. The wider the aperture (e.g. f/2.8, f/4, f/5.6), the stronger the effect. Narrow apertures, such as f/11 and f/16, result in only a very subtle softening of the image, to the extent that at very small apertures the effect all but disappears.

LEFT
Creative filters aren't for everyone, and while they can produce artistically subtle effects, garish results and unnatural colors should be avoided.

RIGHT
Although soft-focus filters are typically used for portraits of people, there is no reason why they can't also be applied when photographing portraits of pets or other animals.

There are many different soft-focus filter models, and all of them have subtle variations in effect. There is no real correct or incorrect soft-focus filter on the market, and in practice it may be impossible to tell the different effects from one to another. Different manufacturers also tend to call filters by different names. For example, Cokin names its soft-focus filters "diffusers," Zeiss makes a series called Softar, Hoya has Softon, and Lee names its soft-focus filters Soft Focus. You may also come across the terms "haze," "sunsoft," and "dream". For many professional users, the Softar range of filters manufactured by Zeiss produce unparalleled quality, but they come at a price, and I would recommend experimenting with some of the less costly versions before making a heavy investment in a top-quality product.

Soft-focus filters also come in different strengths, from very subtle to relatively strong. Again, from a personal perspective, whenever I use soft-focus filters I tend to go with the "less is more" approach, but it is worth experimenting so that when the need to use such a filter arises, you can select the most appropriate strength for the job at hand.

NET FILTERS

Net filters produce similar results to soft-focus filters by using a black mesh to distort fine detail, without compromising overall image sharpness.

A

ABOVE AND RIGHT
Before and after:
a soft-focus filter has
softened the hard lines
in this monotone
portrait (image A)

to give the model
a gentler appeal
(image B).

B

A variation on the straight soft-focus filter is the soft-spot filter, which is typically used in portrait photography. Soft spots, as they are known, have a clear area in the center of the filter that leaves the middle portion of the image sharp and unaffected, while the surrounding area is softened.

The size of the clear area varies, enabling you to use different focal length lenses. For example, wide-angle and standard lenses (28–50mm) need a larger clear spot than short telephoto lenses, which need a smaller clear spot. This is all to do with depth of field—the more depth of field there is, the larger the spot needs to be.

How noticeable the transition is from clear to soft is determined by lens aperture. A small aperture (e.g. f/11 or smaller) will create a more pronounced transition, while a large aperture will make the transition more subtle.

As well as clear soft spots, some manufacturers produce colored versions where the soft-focus area is colored, creating a color cast over the portion of the image it affects.

A

B

LEFT AND BELOW
Before and after: a slot-in soft-spot filter has been used here off-center to soften the background detail in this wedding scene (see image B), while leaving the faces of the bride and pageboy in sharp focus.

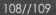

A

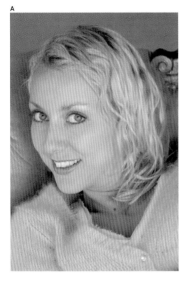

B

ABOVE AND RIGHT
Soft-spot filters are clear in the center. In portrait photography, they ensure that facial features remain sharp, while softening other, less important image details. Image B was taken with a soft-spot filter, and has a sharp center and a softened outer area. In comparison, the non-filtered image (image A) is sharp in detail all over.

When I was young, I can remember watching my father, a keen photographer himself, take a clear glass filter and smear petroleum jelly (such as Vaseline) all over the front of it. He then screwed the filter to the front of his lens and headed off to take some pictures. After he returned and produced some prints in his darkroom, he explained to me the purpose of the petroleum jelly—it acted as a homemade soft-focus filter. As it turns out, there are many techniques you can use to create your own softening filters. Here are a few ideas:

Petroleum jelly: This is the technique my father first showed me, when he smeared petroleum jelly on the front of a clear filter. The amount you apply will dictate the degree of softening, but a blob of around 1–2mm in diameter should be sufficient. Start from the center and work outward until the whole filter is covered with a fine layer. For more abstract effects, smear the jelly in a non-uniform pattern. Petroleum jelly can also be used to create a soft-spot filter, by leaving the center area of the filter clear. Never apply the jelly directly to the lens—always use a clear glass or UV filter.

Condensation on the lens: Breathing on your lens, or preferably on a clear (e.g. UV) filter in front of your lens, will cause condensation to form that creates a fogging effect on your image. The same occurs when you take a lens from a cold environment to a warm one, such as when taking a lens from an air-conditioned room into a humid environment. The problems you are likely to encounter with these techniques are either, in the case of the former, that the fogging will last for a short period, giving you little time to take the image before the condensation dissipates; or in the case of the latter, the uncontrollable nature of the condensation may result in a heavy coating that may take an hour or two to clear.

As an emergency soft-focus filter, however, either of these techniques can be successful. One of my best-selling images was taken this way.

Hairspray: Away from the camera and lens (and any other equipment, for that matter), take a clear glass or UV filter and, from a distance of around 12in (30cm), spray a light covering of hairspray onto it so that the mist settles on the filter. Allow a few minutes for it to dry and then you can use it as a soft-focus filter. For a stronger effect, add an extra layer of hairspray. When you've finished, wash the filter in warm water to clean it. As with petroleum jelly, never apply the hairspray directly onto the lens.

Other DIY techniques: Stretching panty hose over a lens can also act as a soft-focus filter. The higher the denier of the panty hose, the softer the image will appear. Black panty hose will have no effect on color, but to achieve a warming effect similar to that created by the 81 series of filters (see page 70), use flesh-colored stockings. Saran wrap (cling film) stretched over the lens will also achieve a subtle softening effect, which can be enhanced by crumpling it first and then uncrumpling before applying it. Another softening option is to use Anti-Newton glass.

TOP
Petroleum jelly can be used to coat a clear filter to produce a soft-focus effect.

MIDDLE
This image shows the result of using condensation on the lens to produce a soft-focus effect.

BOTTOM
This image shows the result of using petroleum jelly on the lens to produce a soft-focus effect.

SOFT-FOCUS LENSES

There are a few manufacturers that produce soft-focus lenses. These specialty lenses, usually of short-telephoto focal length, are ideal for portraiture photography, where this effect is most commonly used.

LEFT
This image shows the result of using panty hose on the lens to produce a soft-focus effect.

ABOVE
An example of a lens covered with a pair of panty hose, used to create a soft-focus effect.

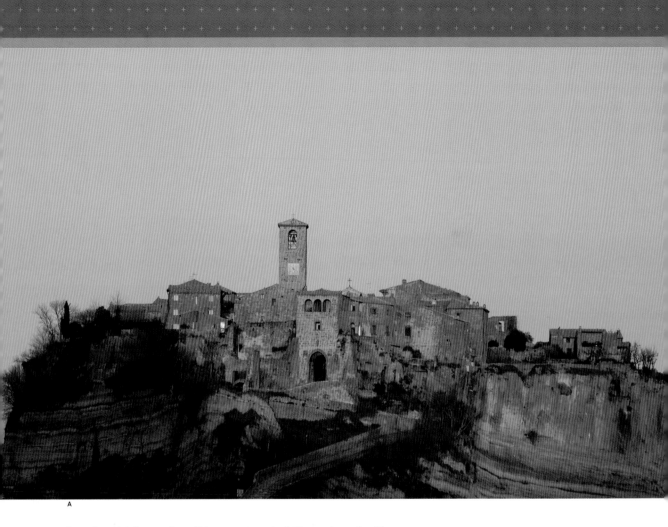

A

Two other variations on the soft-focus filter are pastel filters and mist filters (sometimes referred to as fog filters).

Pastel filters work best with soft, diffused light, and degrade the image to a greater extent than soft-focus filters. The effect can be over-the-top, but used wisely can give an image the feel of a watercolor painting, particularly with landscape scenes. You could also use them in conjunction with a grainy color film to heighten this effect.

Mist or fog filters aim to do exactly as their name suggests—mimic the effects of misty or foggy weather. They do this by scattering the light passing through the filter to soften the overall image, mute colors, and reduce

contrast. Like most creative filters, the results from mist and fog filters can appear very unrealistic if they are used unwisely. To achieve a level of realism, use them for scenes where fog is likely to occur naturally, such as rivers, lakes, and valleys.

Different versions of mist and fog filters are available, including graduated versions, which reproduce the effect of rising mist. They also work well in combination with color balancing filters, such as the 80 series blue filters and the 85 series amber filters.

ABOVE
Before and after: here a mist filter has been used to create a dreamlike effect (image B), compared to the unfiltered version (image A).

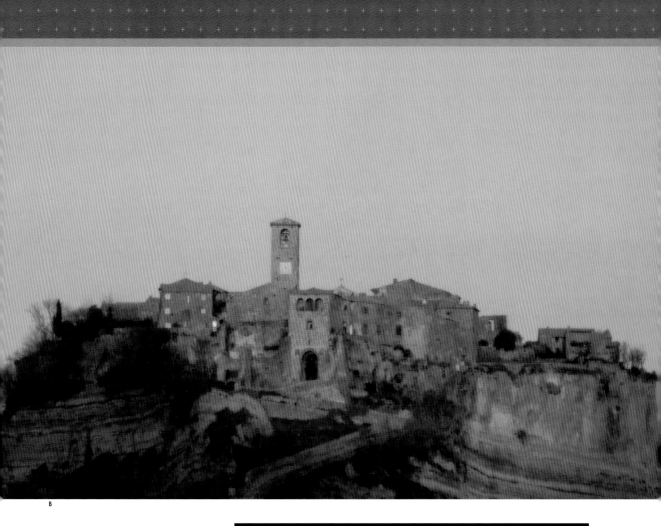

B

TIPS FOR USING PASTEL AND MIST/FOG FILTERS

It's a good idea to experiment when using pastel filters. Exposure can be tricky, and depending on the subject matter, you may need to overexpose for the shot. For creative effect you can combine pastel filters with orange and blue filters, or even with star or mist/fog filters.

While mist/fog filters can create unrealistic effects when used out of context, this doesn't mean you shouldn't experiment. Using mist/fog filters in portraiture photography can create an ethereal soft-focus effect; in bright sunlight they can create haloes of light, and they can also be used effectively to hide busy backgrounds. Remember that mist/fog filters have different density values, so in general, the higher the value the thicker the fog. Fog/mist filters can also be stacked together to create even stronger effects.

The main purpose of colored filters is to balance color casts in color photography (see page 70) or to manipulate contrast in black-and-white photography (see page 94). They can also be used for creative effect in much the same way that WB in digital photography can be used in a non-technical way to alter the color element of a composition (see page 146).

Colors can affect our emotional, and sometimes physical, responses to visual stimuli. For example, blue is associated with cold weather, and can make a person feel physically cooler. Red, on the other hand, is a warm color that we associate with fire, and will have the opposite physical effect to blue. Yellow and orange are also warm colors that will make us feel warmer and also affect our mood. For example, while red is associated with danger and makes us feel apprehensive, yellow is a color of joy and rebirth, and can create a sense of happiness. These color associations can be used creatively in color photography to communicate subliminal messages and affect how the viewer responds emotionally to the image.

COLORED FILTERS AND WB

Remember that when set to AWB mode, a digital camera will attempt to correct any introduced color cast automatically, and that WB should be set to an appropriate Kelvin value to achieve maximum effect (see page 69).

A

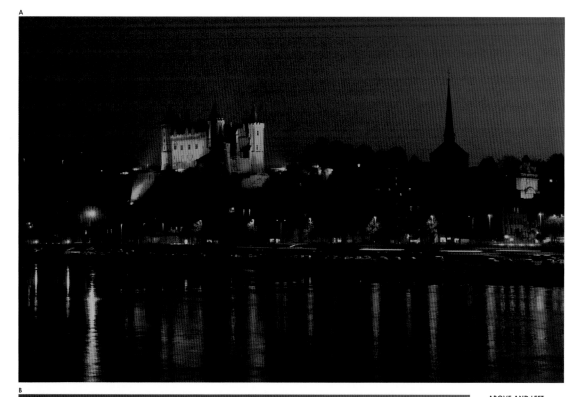

B

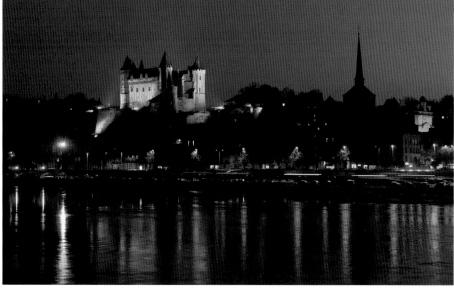

ABOVE AND LEFT
Using a red filter
on this nighttime
cityscape (image A)
has given the scene
a warmer tone in
comparison to
image B.

FAR LEFT
A blue filter has been
used to enhance the
mood of this portrait.

A

Graduated colored filters have the effect of changing the color cast in the part of the scene where the colored half of the filter falls. They are typically used to add color to dull skies or to enhance or change the color of the sky. They come in a variety of colors and should be used wisely and sparingly, always remembering that filters will rarely have the ability to turn a poor scene or subject into a stunning one.

Choosing wisely
A quick review of one manufacturer's website reveals graduated filters in a range of colors, from blue to orange, yellow to purple, pink to turquoise, and tobacco to green. While a green or yellow sky might appeal to some, colored graduated filters work best when they are used to enhance colors that occur naturally rather than change them drastically. For example, a mild blue graduated filter will

enhance a light blue sky to appear more vivid. Similarly, a mild amber graduated filter will help to enhance the naturally warm colors of sunset and sunrise. My point is that colored graduated filters work best when they match the color that appears naturally in the scene.

B

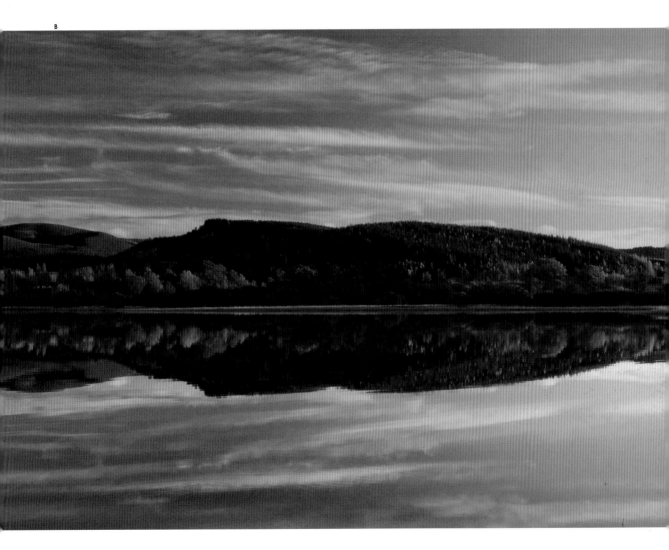

**ABOVE LEFT
AND ABOVE**
When compared
to image A, it is clear
to see that a blue
graduated color filter
has effectively
deepened the color
of the sky in image B.

A

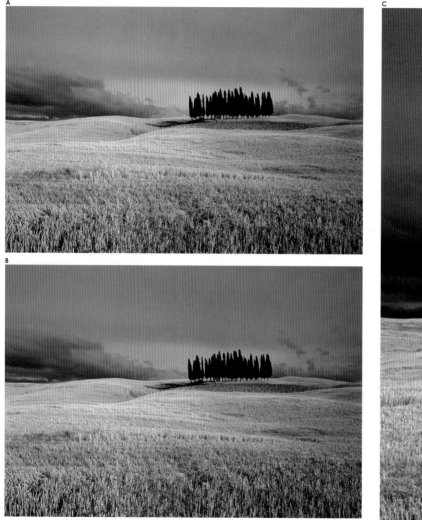

B

C

TOP, ABOVE, AND RIGHT
This series of three images
shows the effects of two
diferent graduated color
filters. Image A shows the
original scene; a blue
graduated color filter was
used in image B; and a
sepia graduated color
filter was used in image C.

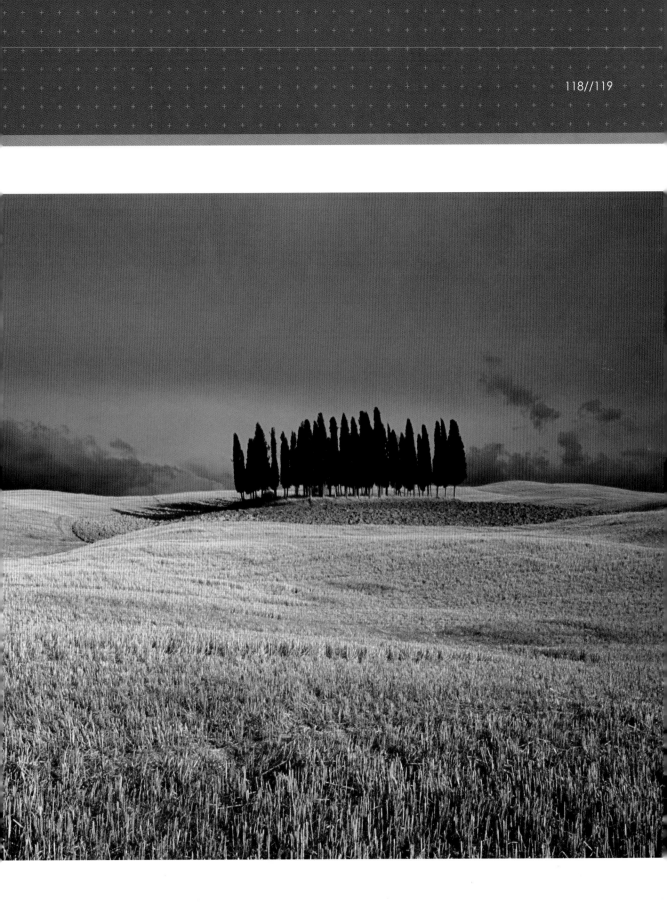

A

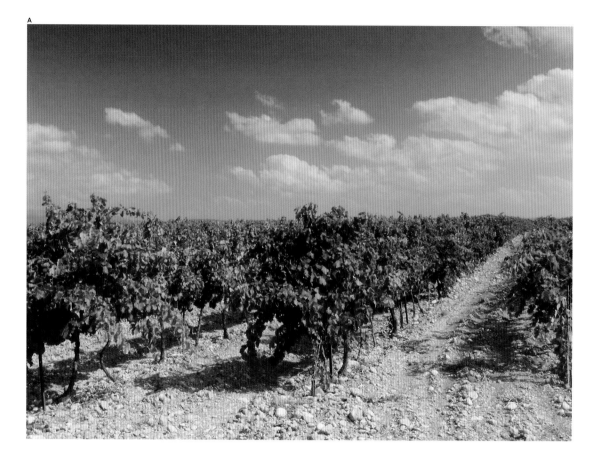

Some colored graduated filters are multicolored, meaning that one half is colored one tint and the other half is colored another. This enables you, for example, to use one color to alter or enhance the sky, while also allowing you to apply a different color to the lower half of the scene.

For example, imagine photographing sand dunes set against a pale blue sky. Compositionally, the image would be more striking if the sky were a deeper blue and the sand a deeper orange (partly due to the fact that orange is complementary to blue). By using a half blue/half amber-colored filter, it would be possible to achieve this effect.

If the desired combination of colors is unavailable off the shelf, some manufacturers, such as Lee Filters, will purpose-make a filter to match your needs (at a cost, of course!). Another cheaper option is to get two standard colored graduated filters of the required tint and invert one over the other.

ABOVE LEFT AND ABOVE RIGHT
Here I used a blue/ 81B combination (split) filter when taking image B to enhance the blue sky and add warmth to the foreground tones that were slightly lacking in image A.

B

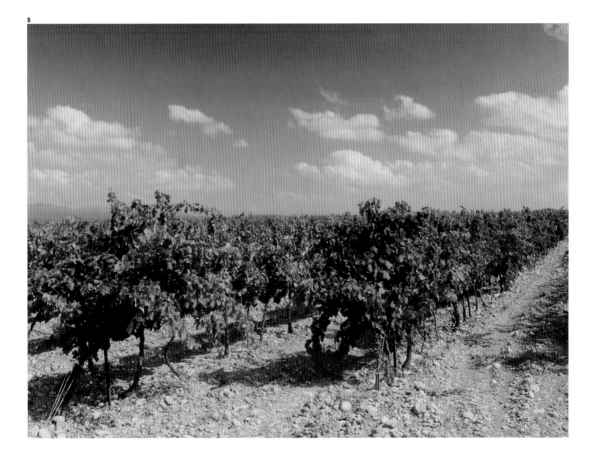

ALIGNMENT

As with GND filters, it is important to accurately align colored graduated filters. For tips on alignment techniques, refer to pages 62–63.

DENSITY AND EXPOSURE

The density of a colored graduated filter may result in some level of light absorption, which must be accounted for when setting exposure. This can work in your favor if there is a need to manage SDR (see page 12).

LEFT
Diffraction filters
cause a halo of color
to surround points
of light or highlights.

USING DIFFRACTION FILTERS WITH NON-SLR CAMERAS

As with polarizing filters, the effects of diffraction (and star filters; see pages 124–125) can be seen in the viewfinder of SLR cameras (or on the viewing screen of view cameras), which makes them easy to apply. However, when using a non-SLR camera the effect of the filter won't be visible. Instead, use the same technique as that for polarizers with non-SLR cameras, described on page 92.

Diffraction filters (diffractors) work by breaking up light into the colors of the spectrum, creating rainbow-like streaks or haloes around highlights and point sources of light. Various pattern types are available, typically 1- and 3-point patterns, which create streaks or circles of diffracted light. Working on the theory that less is more, subtle patterns often produce the best results but, if you're so inclined, it is worth experimenting with the various patterns available.

For the most striking effect, these filters are often best used at night. However, they will work equally on any bright point of light, including the sun, although it is often better if the sun is partially hidden behind a foreground object. Small points of light often produce a more colorful effect and these filter types are therefore best suited (but not restricted) to wide-angle lenses. For an even more colorful effect, try rotating the filter during exposure or, with a zoom lens, zooming in or out during exposure.

Star filters are similar to diffraction filters in that they use points of light to create effects. Instead of separating the different colors of the spectrum, however, fine lines etched into the surface of the filter create controllable flare, which appear like stars. As with diffractors, different patterns are available, including 2-, 4-, 8-, and 16-point stars, and the best effects are usually achieved at night. Beware of scenes where there are lots of lights, however, as your image may become cluttered with too many starbursts.

Star filters can also achieve subtle effects when used during the day. For example, on a sunny day highlights on the water's surface can be turned into a shimmering sea of fine stars that transform the image without overpowering it. They can also be used to create a softening effect on bright light passing through a mosaic of leaves.

As with all special-effects filters, it's worth taking time to experiment. This is far easier when using the instant playback feature on a digital camera. For example, rotating the filter or zooming in or out with a zoom lens during long exposures will alter its effect. The key is to use star and diffraction filters sparingly, and only when they will enhance the composition.

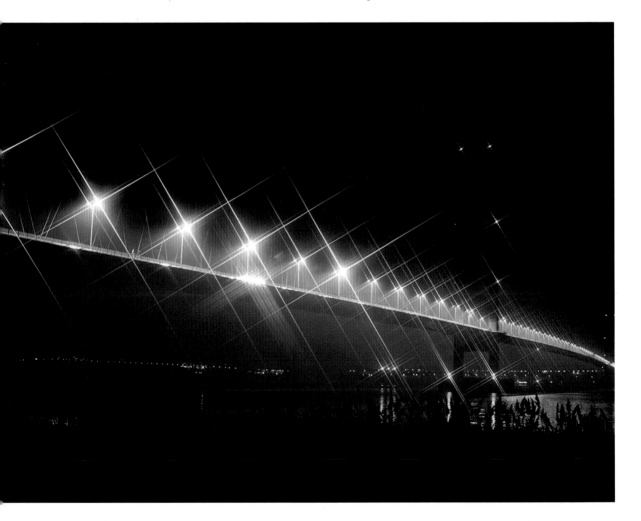

COMBINING STAR FILTERS

Star filters can be combined with other filters, such as color balancing filters, colored filters, and soft-focus filters to achieve a range of creative effects.

BELOW LEFT
This image shows the effects of a 4-point starburst filter.

BELOW
This image shows the effects of an 8-point starburst filter.

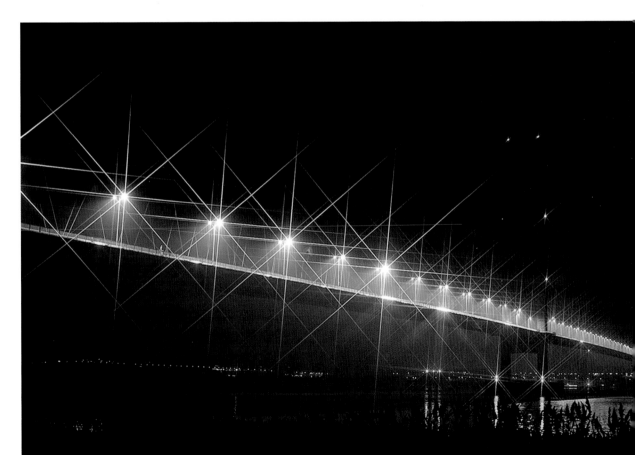

While close-up filters aren't technically considered filters, I have included them here because they are popular accessories, particularly for novice photographers who want to try close-up photography but can't justify spending lots of money on a macro lens or specialist close-up equipment, such as bellows, until they are sure it is a style of photography they want to develop.

Close-up filters are optical attachments that fit onto the front of the lens, reducing the minimum focusing distance. They work by shifting the plane of focus of the camera lens from infinity to a distance corresponding to the focal length of the close-up filter. They are available in different magnifications, measured in diopters, usually +1, +2, +3, and +4 (although higher diopter filters are available from a few manufacturers). They can also be used in combination with one another, so adding together +1 and +4 creates a +5 diopter filter.

The higher the diopter value, the closer the filter will enable you to focus. For example, a +1 diopter filter has a focal length of 3 ⁵⁄₃₂ft (1m). For clarity, it's best to think of the diopter value as fractions, e.g. +1 equals 1, +2 equals one half, and so on. So, for example, if you attach a +1 close-up filter and focus on infinity, sharp focus will be at 3 ⁵⁄₃₂ft (1m). If you attach a +2 diopter filter, sharp focus is at 1 ⁴¹⁄₆₄ft (½m) when the lens is focused on infinity. Focusing

at a distance closer than infinity will bring the focus point closer. The system works irrespective of the actual focal length of the lens used.

The table below gives the reproduction ratios of various diopter close-up filters. This can be used to determine how close to life-size the subject will reproduce on 35mm film (or a digital equivalent) using a 50mm standard lens focused on 3 ⁵⁄₃₂ft (1m). For example, a +1 diopter close-up filter gives a reproduction ratio equivalent to ¹⁄₁₀ life-size; a +4 diopter close-up filter gives a reproduction ratio of ¼ life-size. The higher the diopter of the filter, the closer to life-size the reproduction ratio.

Image quality
There are some considerations that need taking into account when using close-up filters. Compared to other filters, close-up and macro accessories are of a relatively poor quality, which will adversely affect image quality. This is exacerbated when two or more close-up filters are combined to achieve higher reproduction ratios. Adhering to a few basic rules will help to optimize image quality. First, only use prime (non-zoom) lenses within the 50mm to 135mm range. Second, select a lens aperture of either f/8 or f/11; these are the settings at which most lenses give their best optical performance. Third, when combining close-up filters, fit the most powerful first and the weakest last. And finally, always try to use a tripod.

ABOVE
Close-up filters are available in different reproduction ratios.

Depth of field
Because close-up filters result in reduced camera-to-subject distances, depth of field is greatly reduced, even at small apertures, as with any close-up or macro situation. This requires you to pay careful attention to selecting a focus point when composing the image and that you take the necessary precautions to minimize camera shake.

Advantages and disadvantages
Close-up filters do have many advantages. They are inexpensive when compared to the alternatives and are easily carried around in the field. They work with the camera's automatic metering and focusing (as opposed to many other close-up accessories), and there is no light loss, so a handheld meter or non-TTL system is simple, and focusing and composition are unimpaired by a darkened viewfinder. Their main disadvantage is a lack of image quality from their relatively low-quality optics.

REPRODUCTION RATIOS OF CLOSE-UP FILTERS	
Close-up filter (diopters)	**Reproduction ratio**
+1	1:10
+2	1:6
+3	1:5
+4	1:4
+5	1:3
+6	1:2.5

LEFT AND ABOVE
Close-up filters can
produce life-size and
higher reproduction
ratios, but the quality
is poorer than that
produced by macro
lenses and other
close-up photography
accessories.

SPLIT-FIELD FILTERS

Split-field filters are essentially close-up filters that have been cut in half. They can be used to achieve the appearance of incredible depth of field by creating two focus points. For example, if you use a split-field filter of +1 diopter and focus the lens at infinity, then the part of the scene occupying the clear area of the filter will be in focus at infinity and the part of the scene covered by the filter's half of the lens will be in focus at 3 ⁵⁄₃₂ft (1m), effectively creating depth of field from 3 ⁵⁄₃₂ft (1m) to infinity. Used cleverly, this can create some interesting opportunities for close-up photography to reveal a sense of place.

ABOVE
Because infrared film is sensitive to visible light as well as infrared light, a special infrared filter is needed to block visible light and only pass infrared light.

Infrared photography is possible when special film is used or when a digital image sensor is made sensitive to infrared light.

The only black-and-white infrared film still on the market is the Ilford SFX 200, available in 35mm and 120mm roll film format. Kodak and Konica have both discontinued their black-and-white infrared film products. Ilford SFX is a medium speed (200 ISO) film that has extended red sensitivity—technically it is not a true infrared film, but with the correct filtration it can produce infrared effects.

INFRARED WAVELENGTHS

Referring to the diagram below, infrared wavelengths fall between 700 and 1,200nm. The part of the spectrum used in photography is referred to as near-infrared (to distinguish it from far-infrared, which is the domain of thermal imaging) and includes wavelengths in the range of 700 to 900nm.

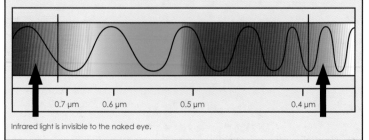

0.7 µm 0.6 µm 0.5 µm 0.4 µm

Infrared light is invisible to the naked eye.

To take in-camera infrared images with a digital camera requires modification of the camera's sensor. Photosensors are inherently sensitive to infrared light (up to about 1,100nm) and have a special filter built into their construction to block infrared wavelengths so that they don't interfere with normal image-making. A qualified engineer can remove this filter and replace it with one that blocks visible light, effectively turning the camera into a specialist infrared camera.

Photographing using infrared wavelengths can produce surreal images with dreamlike effects. This is most noticeable in foliage, which shows as brilliant white, and in skies, which are rendered almost black. In turn, darkened skies result in less infrared light in shadows and dark reflections, and clouds will stand out strongly. These wavelengths also penetrate a few millimeters into skin and give a milky look to portraits, although eyes often look black.

Infrared effects on film are enhanced when infrared filters are used. The main purpose of these filters is to block wavelengths in the visible light spectrum that would otherwise diminish the effects of the infrared wavelengths.

Filters for black-and-white infrared photography
Two types of filter can be used with black-and-white infrared film. The most common are red filters, such as the Lee 25 Tricolor, Cokin 003, Tiffen 25, B+W 092, and Kodak Wratten 25 and 29.

Red filters will block blue and green wavelengths, while passing red and infrared wavelengths above 580nm, giving a strong infrared effect. The advantages of red filters over true infrared filters is that they enable you to still see the scene through the viewfinder of a reflex camera (or on the viewing screen of a view camera), which makes composition and focusing possible in the normal manner, and means that auto TTL metering systems will work effectively. This makes the whole infrared process akin to taking a normal photographic image.

The second option is a specialist infrared filter, such as the Lee 87 IR, B+W 093, Kodak Wratten 87C, and Tiffen 87 IR. These filters block all visible light, passing only infrared wavelengths, which creates the strongest infrared effects. However, their increased effectiveness comes with several disadvantages. Because they pass only infrared wavelengths, which are invisible to the naked eye, infrared filters are opaque. Therefore, composition and focus must be done before the filter is in place. Automatic metering also becomes defunct, as camera light meters are designed to measure visible light, not infrared radiation. ISO ratings also become meaningless as effective speed for infrared varies depending on the subject and weather conditions. All in all, this makes handheld infrared photography near impossible.

Filters for color infrared photography
There are no color infrared films currently available on the market, although it may be possible to pick up out-of-date canisters of Kodak Ektachrome EIR. This film consists of layers, all of which are sensitive to blue light. Kodak recommends that a Wratten 12 yellow filter (or equivalent) is used at all times to block out blue light waves, passing only green, red, and infrared wavelengths.

Other colored filters can also be used with Ektachrome EIR to achieve different results. An orange filter, for example, has a similar effect to that of a yellow filter, producing rich blue skies, white clouds, and vibrant orange foliage. Adding a polarizer when using a yellow or orange filter will increase contrast and produce even more vivid colors. A red filter in addition to a yellow filter will block green light waves, resulting in foliage looking deep red and skies having a yellow color cast. Green will add a magenta cast to the whole scene.

INFRARED AND THE WEATHER

Weather plays a large part in infrared photography. For example, there is more infrared radiation present when the weather is bright and sunny, so these conditions will produce the strongest infrared effects, as shown in the image below.

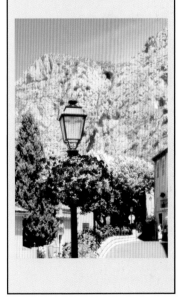

SECTION 4

DIGITAL FILTERS

One of the most distinct advantages of digital photography in comparison to film is that so much of the process can be done after the point of capture, including, to a great extent, filtration.

In the days before digital, a landscape photographer may well have invested a considerable amount of money in filters that then had to be carried around in the field. This might have included a set of four different warming filters, a couple of cooling filters, several color compensation filters, a set of four or more filters for black-and-white photography, a couple of soft-focus filters, and maybe even a star filter. And, if using screw-in type filters, three or four different sizes of each may well have been needed to fit different lenses. In all, this may have amounted to over 100 filters cluttering up a kitbag—and that's not even including polarizers and ND filters!

My point is, whether you agree with the principle of postcapture processing or not, there's no doubt that it has made life easier for many photographers in a practical sense. The aim of this final section, then, is not to debate the ethics of digital processing but to explain how computer processing can replicate the effects of many technical and special effects filters. That said, it is worth noting that there are some filters that must be applied at the point of capture. For example, it is near impossible to mimic all of the effects achieved by polarizing filters in-computer. Similarly, although in some cases digital image merging and high dynamic range imaging can overcome the limitations of camera dynamic range, in a single image, postcapture filtration tools won't be able to reclaim lost detail in a washed-out sky or fix high levels of noise and digital banding in areas of dense shadow.

In the practical world, there is a place for both digital and optical solutions. This section of the book reveals when a digital solution is realistic, and how to apply that technology in an effective manner.

What are digital filters?

As it relates to this book, the term "digital filters" refers to adjustments and techniques that, when applied, replicate or mimic the effects of optical photographic filters. This distinguishes them from tools that are found in the Filter menu in Photoshop, which can include Sharpen, Render, Stylize, and Distort. On the whole, these filter tools have been excluded here, except when they play a distinct role in the replication process.

Software solutions

There are quite a few software solutions available for mimicking the effects of optical filters. Photoshop has a limited number of predefined filters under the Adjustments menu (Image >> Adjustments >> Photo Filter), although these are generally limited to warming and cooling filters of different tints, as well as a range of colored filters. Of course, Photoshop can be used in other ways to make color adjustments that replicate all types of optical color balancing filters, black-and-white contrast manipulation filters, and various special effects filters.

BELOW
Input devices such as graphics tablets help with precise in-computer image adjustments.

TOP RIGHT
Whether you agree with it or not, post-capture processing is a reality in the digital age.

Additionally, there are some stand-alone software solutions, some with compatible plug-ins that integrate them into Photoshop, that provide many more predefined filter options. Such packages include Color Efex Pro 3.0 from Nik Software and Dfx v.1.0.5 from Tiffen (who also make optical filters).

The choice between one software package and another is usually based on the quality of the product, its usability, and its integration into an existing workflow. Because we all have different levels of skill and various ways of working, it's near impossible to recommend any one package over another. As much as possible, I try to limit all my processing work to Photoshop, predominantly to optimize my workflow, although occasionally I'll find that the tools in another independent package are sufficiently superior to warrant its use. Many software manufacturers offer free trials of their products and my advice is to try several versions before committing to one.

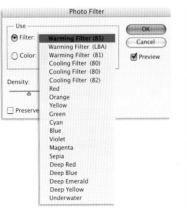

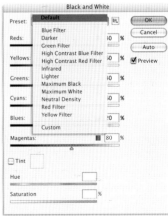

ABOVE AND MIDDLE
Photoshop has a number of predefined filters that can be applied

via the Adjustments menu. On the whole, these are limited to sets of colored filters.

ABOVE
As well as the Photo Filter menu option, Photoshop has a predefined set

of black-and-white filter settings to create monotone images.

Before conducting any digital processing, in order to maximize image quality it is important that you start with a high-quality image. Digital images should ideally be captured in RAW mode, as RAW files have the advantage of being unprocessed. This means that any enhancements or adjustments made in-computer are applied to the very original data captured by the camera rather than being a reprocessing of already processed data. In traditional photographic terms, the difference between a RAW file and a JPEG or TIFF file is akin to the difference between an unprocessed roll of film and a Polaroid print, in that processing a roll of unprocessed film will produce far superior results than trying to reprocess a Polaroid print.

When you begin the RAW conversion process it is important to make sure the image parameters are set correctly. In Adobe Camera Raw (ACR) these details are found at the bottom of the workspace. ACR comes with Photoshop and Photoshop Elements, and is the most widely used RAW conversion software. The following settings should be selected from the relevant ACR drop-down menus:

Space: select Adobe RGB (1998)
Depth: select 16 Bits/Channel
Size: select the default image size
Resolution: select 300 pixels/inch

When using other RAW conversion software solutions, the above settings will still apply.

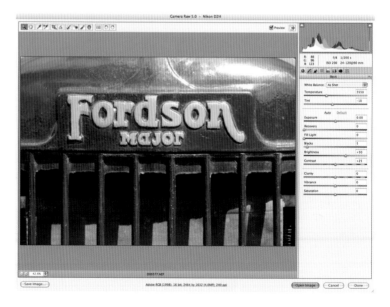

TOP AND MIDDLE
In order to maximize image quality, ensure the correct settings are applied before any image processing begins.

ABOVE
Before applying filter effects via any software solution, it is important that the original image is of the highest quality. RAW images should be converted using appropriate software, such as Adobe Camera Raw (shown here) or Lightroom.

RIGHT
Adobe Camera RAW ships with Photoshop CS3 and above and has undergone a few changes. The Workflow Options are now edited via a separate window, and a raft of new adjustment sliders have been added. A useful visual guide to indicate what the effect will be when the sliders are moved to the left or right has also been added.

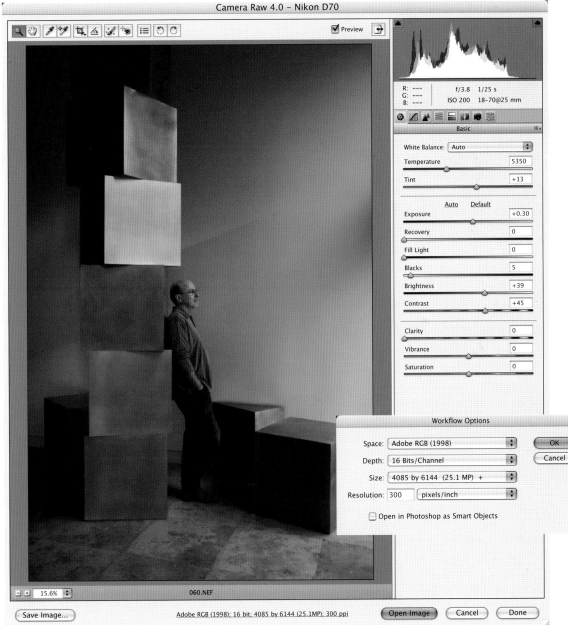

BEFORE

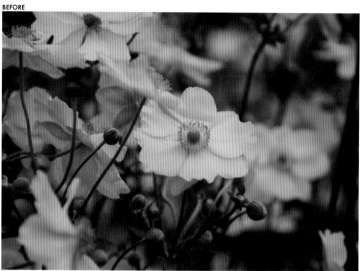

On the whole, color balancing filters are used to neutralize color casts caused by variations in the color temperature of light. There are several ways to digitally color balance an image, and I will describe the two most effective and simplest to apply below.

**Neutralizing color casts
(for TIFF and JPEG files)**
This technique uses the Photo Filters adjustment tool in Photoshop. It can be used to remove or lessen warm (orange) or cool (blue) color casts to produce a more natural-looking image. This technique is also best suited to preprocessed images saved in either JPEG or TIFF file mode.

AFTER

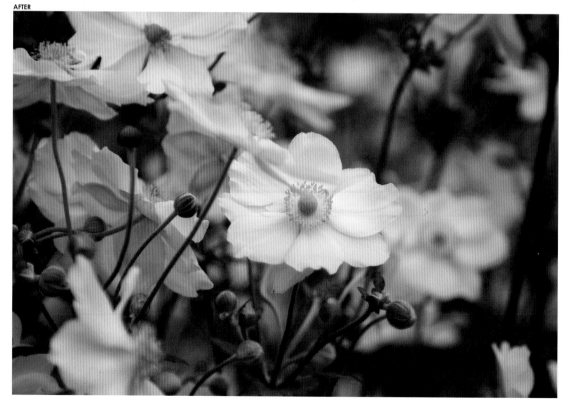

1. With an image open in Photoshop, add a new Photo Filters Adjustment layer (Layer >> New Adjustment Layer >> Photo Filter).

2. In the New Layer dialog box, give the layer an appropriate name, e.g. "Color Balance," and click OK. This will open the Photo Filter dialog box.

We are now going to sample the color cast that we want to remove from the image.

3. Move the cursor over the colored box next to the option labeled "Color" and click on it. This will bring up the Color Picker dialog box.

4. Move the cursor over the image (the cursor icon will change to show an eyedropper) and select a point on the image where the color cast is most noticeable. Click on this point with the eyedropper. This will bring up the Select Filter Color dialog box, with the selected color shown.

To neutralize the color cast, the selected color must be inverted so that its opposite color can be applied to the problematic image.

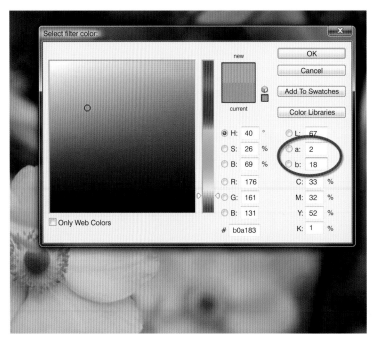

5. To invert the selected color, in the Select Filter Color dialog box go to the value boxes marked a: and b: (right column, second and third boxes from the top). If the value shown in either box is a positive number, add a minus symbol in front of the given value. If either value shown is already negative, remove the minus symbol. This will result in a new color, which is the exact opposite of the original color being shown in the dialog box.

6. Accept the new color by clicking OK.

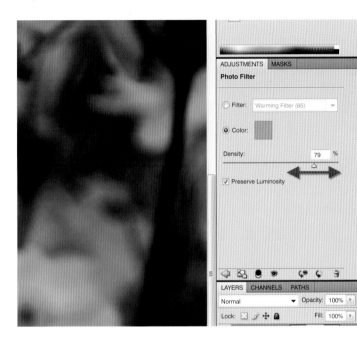

We are now going to apply the Photo Filter to neutralize (or reduce) the effects of the color cast.

7. In the Photo Filter dialog box, drag the Density slider to a point where the warm or cool cast has been neutralized (or reduced to a satisfactory level). Ensure the Preserve Luminosity box is checked. To accept the adjustment, click OK.

8. You may find that the colors have been muted by the adjustment. This can be rectified by adding an appropriate amount of saturation using the Hue/Saturation Adjustment tool from the Image >> Adjustments menu. Apply an amount between 5 and 25 for natural-looking colors.

Neutralizing color casts using Levels

An alternative to the previous method of correcting color casts is to use the Levels Adjustment tool. This is the preferred method when color casts are not confined to warm (orange) or cool (blue) casts.

BEFORE

AFTER

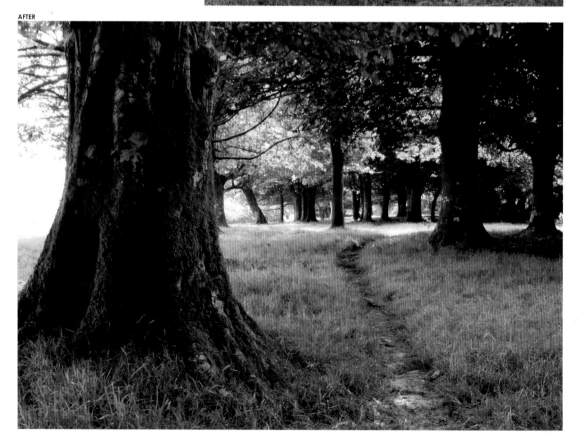

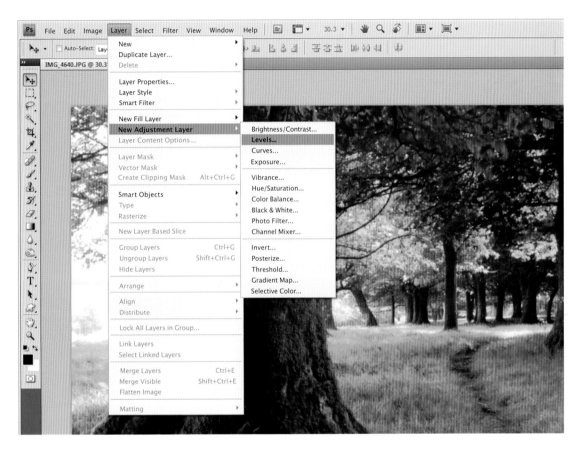

1. With an image open in Photoshop, add a new levels adjustment layer (Layer >> New Adjustment Layer >> Levels).

2. In the New Layer dialog box, give the new Adjustment layer an appropriate name, e.g. "Color Balance," and click OK. This will open the Levels dialog box.

3. Double-click the black eyedropper icon. This brings up the Select Target Shadow Color dialog box. Set the value of the # box to 0d0d0d. Click OK.

4. Double-click the white eyedropper icon. This again brings up the Select Target Shadow Color dialog box. Set the value of the # box to f2f2f2. Click OK.

5. Select the black (left side) eyedropper tool. Moving the cursor over the image, click on an area that represents the darkest part of the scene.

6. Select the white (right side) eyedropper tool and, moving the cursor over the image, click on an area that represents the brightest part of the scene.

Tip: To locate the darkest point of an image, open the Levels dialog box (Image >> Adjustments >> Levels). Hold down the Alt (PC)/Option (Mac) key and drag the shadows (black) slider to the right, to the point where shadows begin to show in the histogram. The areas showing black indicate the darkest part of the scene. To locate the brightest part of the scene, follow the same procedure using the highlights (white) slider, dragging it to the point where the highlights show in the histogram. The areas showing white indicate the lightest part of the scene.

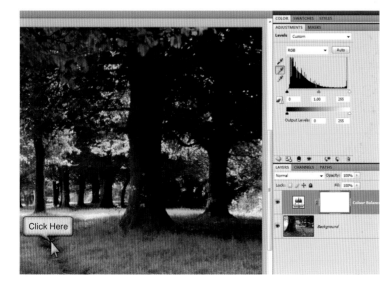

7. Select the gray (middle) eyedropper tool. Moving the cursor over the image, click on an object in the scene that is representative of medium-gray. This will eradicate any color cast. You can experiment at this point by clicking on different tones in the scene until you achieve a result you are happy with.

8. Click OK to apply the changes.

Neutralizing color casts (for RAW files)
Color casts in RAW image files can
be neutralized at the RAW conversion
stage of image processing using
the WB tools in ACR.

AFTER

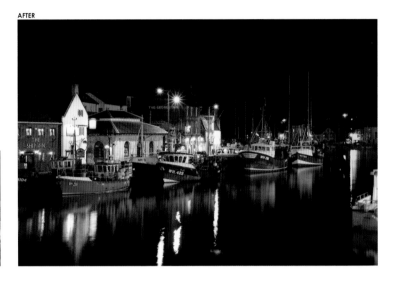

BEFORE

USING THE EYEDROPPER TOOL

A white or gray object in a scene
takes on the color cast caused
by the color temperature of the
ambient light prevalent at the
time of shooting. When you use
the ACR eyedropper tool to specify
an object that should be white or
gray, the software can determine
the color of the light in which the
scene was shot and automatically
make the appropriate WB
adjustments. In practice, I have
found the manual method
described above to be more
accurate when balancing color.

1. Open an image in ACR. This will
open the ACR workspace.

2. Preset WB values can be applied
simply by opening the WB drop-down
menu (by clicking on the blue up/
down arrow keys) and selecting
an appropriate setting, as outlined
in the table opposite.

Any Kelvin value between 2,000 and
50,000 can be applied via the Custom
setting, simply by dragging the slider
to an appropriate point on the
Temperature scale. The effect is easily
gauged visually. For reference, any
value below 5,500 will add blue
(reducing orange color casts) and
any value above 5,500 will add
orange (reducing blue color casts).

3. Once an appropriate WB value
is set, click on Done (or Open Image,
to open the image in Photoshop).

PRESET WB VALUES		
Setting	Kelvin value	Effect
Daylight	5,500	Produces an effect similar to that recorded by unfiltered sunny daylight on daylight-balanced film.
Cloudy	6,500	Mimics the effects of a combination 81D + 81D filter, increasing warm (orange) tones, reducing blue casts.
Shade	7,500	Mimics the effects of an 85 filter, increasing warm (orange) tones and reducing blue casts.
Tungsten	2,850	Mimics the effects of a combination 80A + 82B filter, increasing blue tones and reducing orange casts.
Fluorescent	3,800	Mimics the effects of a combination 80C filter, increasing blue tones and reducing orange casts.

Neutralizing green or magenta casts

The Tint slider control, which sits beneath the Temperature slider, can be used to neutralize green or magenta casts that occur either naturally or as a result of WB adjustments.

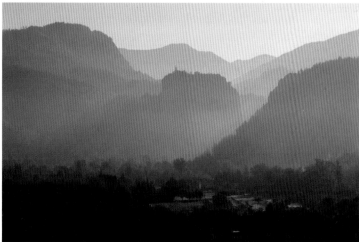

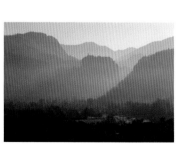

1. To neutralize a magenta color cast, drag the slider to the left. The further left it is, the greater level of green filtration applied. To neutralize a green color cast, drag the slider to the right. The further right the slider is dragged, the greater magenta filtration that is applied.

2. When the image has a natural appearance, click Done (or Open Image) to apply the adjustment.

Digital cameras have a WB control that enables the setting of an appropriate Kelvin value to compensate for the prevailing color temperature of light at the time of shooting. In most cameras there is a set of preprogrammed options, as well as manual options and the obligatory AWB setting.

When set to AWB mode the camera will attempt to replicate the white balance control built into the human brain (see page 42). That is, the camera will always compensate for any color cast in an effort to record light as neutral white light. For example, imagine you are snapping an impromptu family portrait in the living room of your home. It is nighttime and the lights are on. Because the color temperature of a household lightbulb is relatively low (c. 2,500–2,900K), had the photograph been taken at a WB setting intended for outdoor photography the resulting image would have a distinct orange color cast. However, with the WB control set to Auto, the camera will automatically compensate for this color cast and process an image more natural in appearance—closer to how we perceive the color of light.

It's not an exact science, and the image may still have a slight color cast in the same way that if I replace a standard lightbulb with an artist's (daylight) bulb I can see a difference, even though I generally see the light as white light. What is important to remember at this point is that when set to AWB, the camera will always aim to process an image devoid of any color cast.

One could argue that this is a good function—surely we want our images to be free of color casts and looking the way we saw them, but this isn't always the case. Imagine you have risen early, headed to a local lookout, and set up your camera to capture a perfect sunrise. As the sun comes up there is a beautiful golden glow to the light. It appears warm, appealing, and pleasing. You take your shots and head home to look at the images on screen. You upload them to your computer, open up your image viewing software, and there they are—your beautiful sunrise shots looking like you shot them in the middle of the day! Why? Because with AWB set, your camera will compensate for the striking red color cast of the early morning sunrise to create a neutral (white light) image.

In this instance it is desirable that the image has an appropriate color cast in order to capture the glory of sunrise. Had the image been shot on film, it's unlikely that the photographer would have used an 82 or 80 series blue filter to reduce or completely nullify the color effect of the sunrise. If anything, they would have enhanced it with an 81 or 85 series filter. The question, then, is how do you stop your digital camera from processing images that always look like they've been photographed under a midday sun?

Referring to the generalized color temperature diagram for daylight (see page 69), when a digital camera is set to AWB it will always attempt to compensate for color casts (red at sunrise, orange in the early morning, and yellow at midmorning) to process an image that appears neutral (white light). Arguably, then, you should avoid using the AWB option unless you specifically want to create a neutral appearance in your image.

A

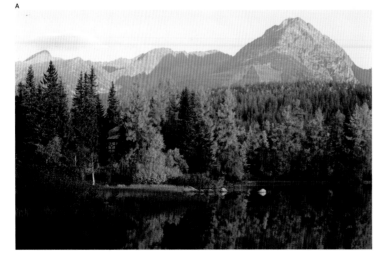

LEFT AND RIGHT
AWB will attempt to neutralize color casts, as seen in image A. Consequently, this setting should be avoided when color casts are beneficial to the composition, such as the scene in image B, which was shot under the golden glow of early morning sun.

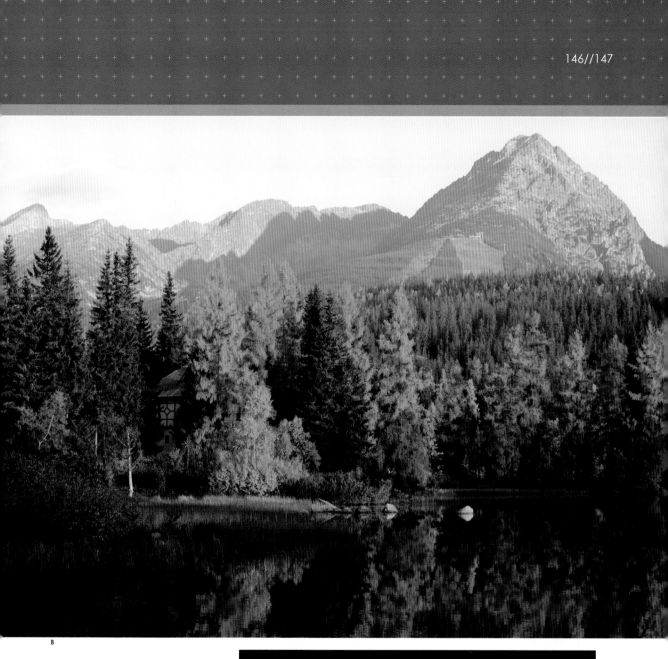

B

AUTO WHITE BALANCE

The most important thing to remember about color temperature when shooting digitally is that when set to AWB, your camera will always aim to remove color casts in an effort to record light as neutral white. If setting your camera to AWB will hinder the effect you require, for example a warm sunrise scene, set your camera to the Daylight preprogrammed setting (see page 148).

Preprogrammed WB settings

As well as AWB, digital cameras have a number of preprogrammed WB settings that are identified in the WB menu via a set of icons:

Shade

Cloudy

Flash

Daylight

Fluorescent

Tungsten

These settings can be thought of in terms of CT correction and color conversion filters. Let me explain:

Daylight: the daylight setting is the equivalent of daylight-balanced film with no filtration. At this setting, the camera will record any color cast caused by the color temperature of light being higher or lower than average daylight at around midday.

For example, referring to the sunrise photo session described on page 146, with WB set to Daylight the camera would record the red color cast of the low temperature light, giving the image a warm tone. That is, it would record the sunrise much closer to how you expect a sunrise to appear.

Similarly, if you were to snap your impromptu family portrait in the living room under a standard household lightbulb, the camera-processed image would have a strong red color cast because when set to Daylight

it doesn't compensate for color casts. This would result in the portrait having a strong, unnatural red color cast, similar to if the same image was shot with daylight-balanced film.

Tungsten and fluorescent: these two WB settings are the equivalent of the 80 series blue filters, with the effect of filtering red light waves. Tungsten is a strong blue color (similar to an 80A filter), and fluorescent a mild blue (similar to an 80C filter).

Again referring to the examples already described, in the case of the family portrait, setting WB to Tungsten would have the effect of filtering the red color cast caused by the low color temperature of a household lightbulb, resulting in a more natural looking image.

However, had either setting (Tungsten or Fluorescent) been applied for the sunrise shot, the resulting image would have lost its warm glow because the red color cast would have been compensated for by the WB setting.

Cloudy and Shade: these two WB settings are the equivalent of the 81 and 85 series of amber warming filters, with the effect of filtering blue light waves. The Cloudy setting is the equivalent of a mild amber color (similar to a combination of an 81D and 81EF filter), and the Shade setting is a stronger amber color (similar to an 85 filter).

Going back to our sunrise shot, had the photographer wanted to enhance the red glow of sunrise, setting either of these two WB settings would have intensified the existing red color cast.

In summary, the preprogrammed digital WB settings are similar to having a set of color temperature correction filters built into the camera, which can be applied to compensate for or enhance color casts caused by color temperature.

LEFT
When set to Daylight, the camera will record any color cast caused by a color temperature above (blue color cast) or below (red color cast) the Kelvin value for daylight (c. 5,500K).

RIGHT
With WB set to Tungsten, the camera will record a high level of blue light— an effect similar to having used a strong blue filter.

BELOW
With WB set to Fluoroscent, the camera will record more blue light than red—an effect similar to having used a mild blue filter.

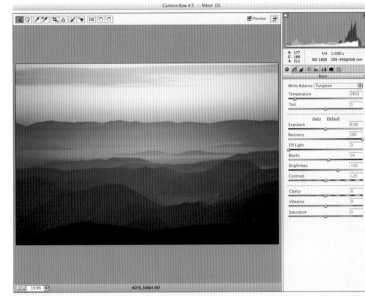

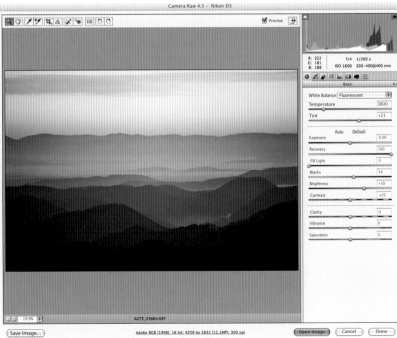

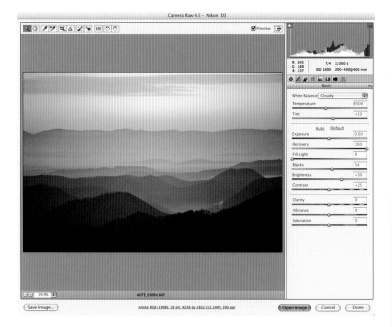

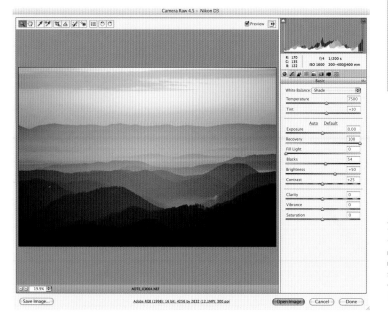

Manually setting WB

As well as the preprogrammed WB settings, digital cameras usually have two manual options.

The first is likely to be indicated by the Manual icon and enables the user to dial in a specific Kelvin value, usually in 50 or 100K increments. Each of the preprogrammed WB settings has a specific Kelvin value, as shown in the table opposite.

PREPROGRAMMED FLASH WB SETTING

There is another preprogrammed WB setting for Flash lighting, marked with a Flash image icon. This setting is ideal for use with electronic flash and is very similar to the Daylight setting, with approximately 100K difference in value. When used with electronic flash it will result in a neutral (white light) image. When used with natural light or with tungsten or fluorescent lighting it will have a similar effect to the Daylight WB setting.

ABOVE LEFT
With WB set to Cloudy, the camera will record a mild orange/red cast—an effect similar to having used a mild orange (warming) filter.

LEFT
With WB set to Shade, the camera will record a strong orange/red cast—an effect similar to having used a strong orange (warming) filter.

LEFT
When photographing
wildlife with a film
camera, I always
use an 81A warming
filter to add warmth
to the image. I can
replicate this in digital
photography by
setting an appropriate
WB value.

WB—SEE FOR YOURSELF

There is a simple exercise you can do that will help you visualize the different effects of each of the preprogrammed WB settings.

1. Set your camera on a tripod and compose a scene. This can be either indoors or outdoors, and using any form of lighting, natural or artificial.

2. Set WB to the Daylight setting and take a picture, making sure it is accurately exposed.

3. Without moving the camera, repeat Step 2, changing the WB setting each time until you have worked through each of the preprogrammed settings (Daylight, Tungsten/Incandescent, Fluorescent, Cloudy, Shade, and Flash).

4. In the camera's LCD screen or on a computer, review the six images and note how the color cast changes in each.

If shooting in RAW file mode (as opposed to JPEG), it is possible to replicate this exercise using a computer and RAW conversion software using a single image. See page 134 for details on how to do this.

As described previously, the Tungsten, Fluorescent, Cloudy, and Shade settings can be compared to 80A, 80C, 81D + 81EF, and 85 color temperature correction or color conversion filters. However, what if you want to create a stronger or milder filter effect? For example, when photographing wildlife I often like to warm the image with an orange color cast. However, from experience I have found that setting WB to Cloudy creates too strong an effect—I prefer something between Daylight and Cloudy. It's not possible to achieve this effect with the preprogrammed settings, but by using the manual K setting I can dial in an exact Kelvin value. For instance, in this example I might set a value of 5,800.

So while the preprogrammed WB settings are the equivalent of having two amber and two blue filters in your kitbag, the manual option gives you an almost endless variation of different strength amber and blue filters. In order to apply them, simply remember that the line in the sand is the Daylight setting, which is around 5,400K. Any value lower than 5,400 will add a blue color cast, increasing in intensity the lower the value; any value higher than 5,400 will add a red color cast, increasing in intensity the higher the value.

KELVIN VALUES FOR PREPROGRAMMED WB SETTINGS

Preprogrammed WB setting	Approximate Kelvin value (exact values may vary between cameras)
Tungsten	3,000
Fluorescent	4,200
Flash	5,300
Daylight	5,400
Cloudy	6,200
Shade	7,500

Setting a custom WB

The second manual option is the custom WB setting, sometimes referred to as a preset. This is often used in studio photography and for photographic applications where the light source is constant. It is also more usual to use custom WB when it is important to capture colors accurately, without any color cast. Examples are portrait photography, where natural-looking skin tones are important; commercial photography, where accurately recording the color of a product is typically part of the brief; and archival photography, where accurate records of historic items are needed.

In these scenarios, the purpose of WB is to enable the camera to record colors as close to their natural state as possible. In order to do this the camera needs to know a precise white point, which is where custom or preset WB comes in. It is important to reiterate that a custom WB value will only be relevant under the exact same lighting and environmental conditions. As soon as either the lighting or the surroundings change, any custom WB setting will become inaccurate.

Setting a custom WB value is similar in many respects to taking a light meter reading and involves the following steps:

1. Position an 18 percent gray card, a piece of pure white card, or matte reflector directly in front of the subject so that it is in the same light. Secure it in place.

2. Set the camera's metering mode to spot or center weighted metering.

3. Set exposure mode to either aperture priority or shutter priority AE mode and set a medium shutter speed or aperture value.

4. On the camera, set WB to the custom or preset setting.

5. Frame the reference card/reflector so that it fills the viewfinder.

6. Take a picture of the reference card/reflector. If you've undertaken these steps successfully, the camera will store the WB value in its memory and use this value until you revert to a different WB setting or set a new custom WB value.

White Balance:	As Shot	
Temperature		5700
Tint		– 8

✓ **As Shot**
Auto
Daylight
Cloudy
Shade
Tungsten
Fluorescent
Flash
Custom

LEFT
Adobe Camera Raw provides a drop-down menu of WB options, which matches that of the preset WB values in the camera.

RIGHT
Because the color temperature of light outdoors often changes, I do all of my WB adjustments during post-capture processing.

EXPODISC

Another method of calculating a custom WB value is to use a product called the ExpoDisc, which looks like a screw-in filter and is attached to the front of the lens in the same way.

Whereas the camera's custom preset WB option works in a similar way to a reflected light meter, the ExpoDisc is more like an incident light meter, in that it reads the color temperature of light falling on the subject rather than reflecting off it. A color temperature reading is taken by standing adjacent to the subject and pointing the camera back toward the position from which the working images will be photographed.

The advantage of an ExpoDisc solution is that it enables the user to measure and compensate for light striking the subject from different angles. A gray or white card (or reflector), on the other hand, is directional and is best for copying flat art, as opposed to three-dimensional objects.

There are two versions of the ExpoDisc, one regular and one that adds a slight warm color cast. The latter is better for outdoor use, where a warm cast often adds to the composition. For accurate color rendition, the regular version should be used.

The ExpoDisc filter from ExpoImaging provides a simple solution to consistently obtain accurate colors.

WB: in-computer versus in-camera

With a digital camera, if you shoot in RAW file mode it is possible to adjust WB during postcapture processing using RAW converter software, such as Adobe Camera Raw, Adobe Photoshop Lightroom, or Apple Aperture. This is because RAW files are not processed in-camera. Instead, when you capture an image in RAW mode the camera stores the unprocessed image data on the memory card along with a file that contains the shooting parameters set, including the WB value. Therefore, when you open the image in-computer you can change the WB value via the software as if you had changed it at the point of capture.

Most RAW conversion software packages provide two options for adjusting WB. The first is via a drop-down menu with preprogrammed settings that largely reflect the preprogrammed options on the camera, e.g. Daylight, Cloudy, Shade, etc. The second is closer to the manual WB option in the camera, whereby a slider can be used to custom set and fine-tune both a temperature value (between blue and yellow casts) and a hue value (green to magenta).

Because I tend to do most of my photography outdoors, and in ever-changing lighting conditions where I have little time available to constantly retake WB readings, I tend to do all of my WB adjustments at the RAW conversion stage of the photographic process using the manual custom sliders. This also has the benefit of giving me a high level of control over the WB value I set. The argument against this approach is that it involves spending more time in front of the computer. This may be true, but because I shoot in RAW mode I have to spend that time converting the RAW files anyway, and building in extra time to set WB makes little overall difference to me.

The above is only true if you photograph digitally in RAW mode. If you shoot in JPEG (or TIFF) mode then the camera will process the image before it stores it on the memory device. Any subsequent adjustments, therefore, involve reprocessing already processed data (known as destructive processing), which may result in degradation of image quality. It will certainly involve a longer and more complex process of image editing.

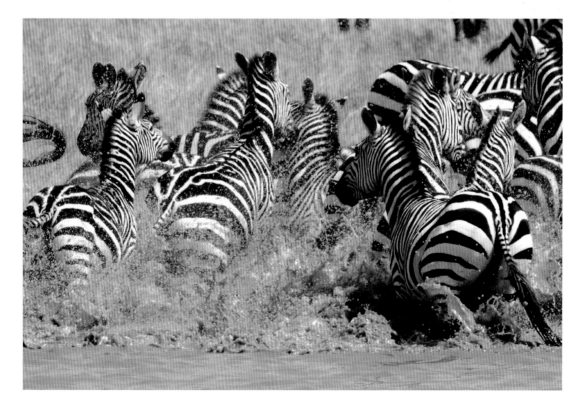

I outlined earlier that the technical purpose of the WB control is to enable a digital camera to record colors in their true state (or at least the state in which we perceive them). It should not be forgotten, however, that photography is a creative process and how we reveal things photographically need not be the way they appear in real life, just as painters don't always paint exactly what they see before them. Photography is just as much about an individual's interpretation as painting, sculpture, or any other art form.

To that end, WB can be used creatively to enhance or even add color. For example, the image shown right was photographed just a few minutes from my home. I had been at our local bird reserve feeding the ducks with my son. As we threw them bread, a huge flock of gulls descended within inches of us, catching chunks of the bread in midflight. I quickly grabbed my camera gear and set up my shot.

I used flash to light the bird, but the main problem was the dull gray sky in the background. It was colorless, lifeless, and made for an uninspiring backdrop. I decided to change the color of the sky to a more dramatic tone and achieved this by setting WB to the Fluorescent setting. Technically, Cloudy would have been the correct setting to use given the conditions, but by selecting Fluorescent I enhanced rather than compensated for the blue light waves that are inherent in overcast light.

As I specialize in outdoor photography, the Fluorescent setting is a real advantage to me. I often photograph landscapes at night using moonlight as the main light source, and setting WB to Fluorescent greatly enhances blue skies, preventing them from fading to a washed-out gray-blue tone.

In the opposite direction, WB can be used to enhance or create warm tones, such as red skies at sunrise and sunset.

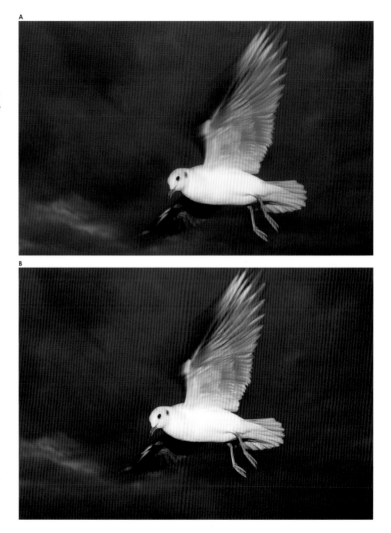

A

B

ABOVE
By adjusting the camera's WB to the Fluorescent preset value I have altered the color of the sky from dull gray (see image A) to a more dramatic blue (see image B).

A

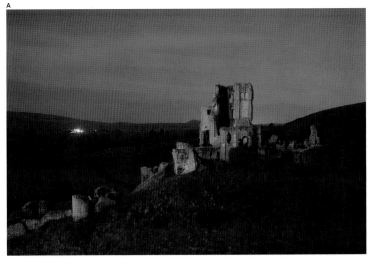

LEFT AND BELOW
Under moonlight,
long exposures dull
the color of the night
sky (image A). Using
the Fluorescent preset
WB setting, I have
enriched the color
of the sky for a more
aesthetically pleasing
effect (image B).

B

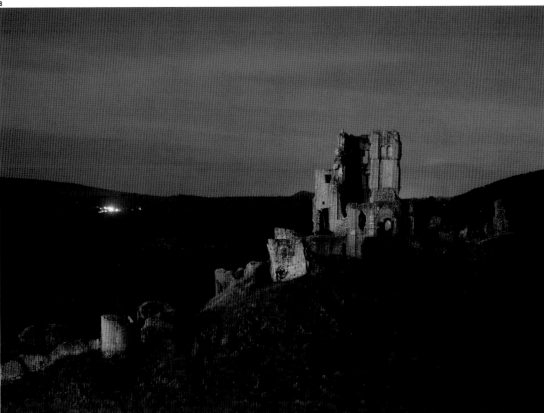

Enhancing colors

At its most basic level, the Photo Filters tool in Photoshop can neutralize or add a warm or cool color cast by using the set of warming and cooling filters in the drop-down menu. However, just as optical filters can be combined to tint and enhance colors, so too can individual filters. The following tutorial shows how this might be applied, in this instance, to a landscape image.

RIGHT AND BELOW Photoshop filters have been used to mimic the effects of a duo-tone blue + amber colored filter, enhancing the blues of the sky and warming the foreground rocks in image B compared to image A.

BEFORE

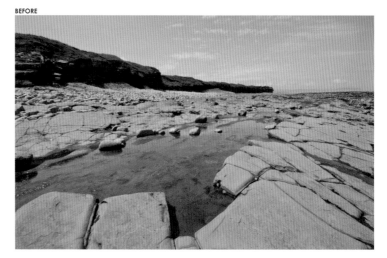

AFTER

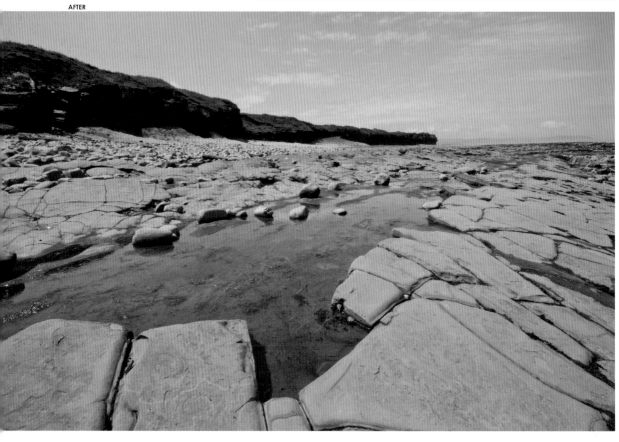

ENHANCING COLORS

Try not to overdo the coloring effect. Subtle enhancements and tints will look far more natural than bold, striking colors that are rarely seen in reality.

1. With an image open in Photoshop, select the Lasso tool (or any of the selection tools) from the Tools menu and make a selection of the area you want to enhance first.

2. To apply a photo filter to the selection, open a new adjustment layer (Layer >> New Adjustment Layer >> Photo Filter). Give the new layer an appropriate name. This will open the Photo Filters dialog box.

3. From the drop-down menu, select the color filter you want to apply. If the filter color you want doesn't appear as a preset in the drop-down menu, click on the color swatch in the Photo Filter dialog box. This will open the Select Filter Color dialog box along with a color picker. Click on the color you want and the filter will be set as this color.

4. You can adjust the intensity of color applied by dragging the Density slider. Dragging the slider to the left decreases intensity, while dragging it to the right increases it. With the Preview option checked, you'll be able to see the effects of adjusting density levels on the open image. Drag the slider until you get an effect you like, then click OK.

Next we're going to add a second color effect to a new area of the image.

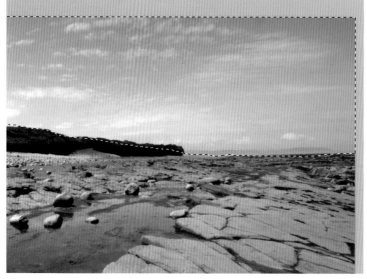

5. Using a selection tool, select the next area of the image you want to affect. In some cases, it may be possible to do a simple inversion (Select >> Inverse) of the original selection.

DIGITAL GRADUATED COLOR FILTERS

By following steps 1 to 4 from this tutorial, it is possible to mimic the effects of using an optical graduated color filter, as described on page 116.

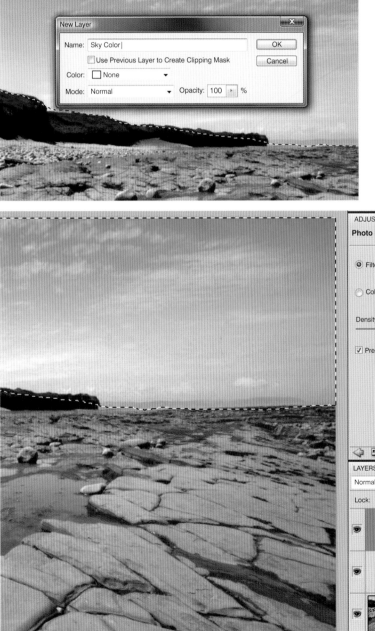

6. Add a second new adjustment layer (Layer >> New Adjustment Layer >> Photo Filter). Give this layer a different name.

7. From the Photo Filters dialog box, choose the filter color you want to work with.

8. Apply the filter as described in step 4.

Because the color enhancements were made using a layer mask, if necessary, the image can be cleaned up using the Paintbrush tool.

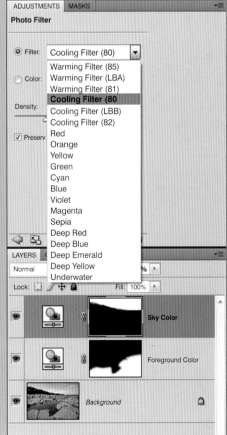

ND filters are typically used to reduce the amount of light entering the lens, enabling the setting of larger apertures for less depth of field or, more often, slower shutter speeds to create motion blur in moving subjects. The next tutorial illustrates how to mimic the effect of an ND filter in order to create an ethereal effect on fast-flowing water, in this case a waterfall, shown in the image to the right.

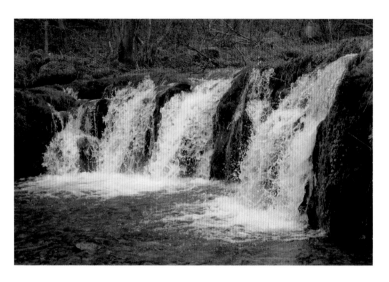

1. With an image open in Photoshop, select the Lasso tool from the Tools menu. Draw a selection around the area to be blurred. The selection doesn't have to be absolutely precise, but try and keep to the edges.

2. Create a new layer (Layer >> New >> Layer). Give the new layer an appropriate name and then copy the selection to the new layer (Edit >> Copy >> Edit >> Paste).

We're now going to add the blur effect to the water.

3. Hide the background layer and select the layer with the copied selection.

4. To add motion blur, open the Motion Blur filter (Filter >> Blur >> Motion Blur). This will open the Motion Blur dialog box.

5. Adjust the Angle setting so that it closely matches the angle of the flow of water.

6. Adjust Distance to increase or decrease the amount of blur applied. Tick the Preview box so that you can see the effects. When you have an effect you're happy with, click OK.

The next step is to clean up the image, removing areas of overlap.

7. With the waterfall layer still selected, add a layer mask by clicking the Add Layer Mask icon at the bottom of the Layers palette.

8. Make sure that black is selected as the foreground color (press D on the keyboard to set the foreground color to black). Select the Paintbrush tool from the Tools menu and select a soft-edged brush of an appropriate size.

9. Using the Paintbrush, brush over any area where unwanted blur occurs.

Although digital filters cannot be used after the event to restore clipped pixels lost at the point of capture, it is possible to replicate the effects of a GND filter to darken selected areas of an image, such as a sky, using the following technique.

BEFORE

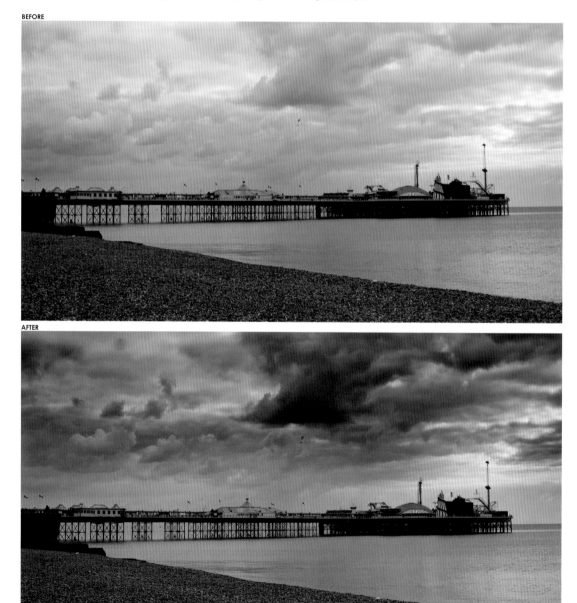

AFTER

1. With an image open in Photoshop, select the Lasso tool (or any of the selection tools) from the Tools menu bar and make a selection of the area you want to enhance first.

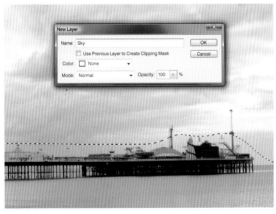

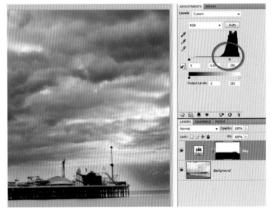

2. Open a new Levels adjustment layer (Layer >> New Adjustment Layer >> Levels). Give the new layer an appropriate name.

3. Use the Input Levels adjustment controls to darken the selected area. The black (left side) slider will increase the depths of shadows but is likely to over-darken the selected area. For a more natural-looking effect, use the gray (middle) slider. Sliding it to the right will darken tones, sliding it to the left will lighten them.

4. When you have an effect you are happy with, click OK.

ALTERNATIVE SELECTIVE EXPOSURE TOOLS

Instead of using a Levels adjustment layer, the same selective exposure effects can be achieved using a Curves adjustment layer.

The following procedure replicates the effects of soft-focus filters, as described on page 106. In this example I have used a portrait image, but the technique is effective on other subjects, including landscapes and still life.

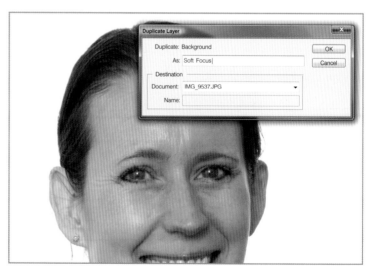

1. With an image open in Photoshop, create a duplicate background layer (Layer >> Duplicate Layer). Give the duplicate layer an appropriate name.

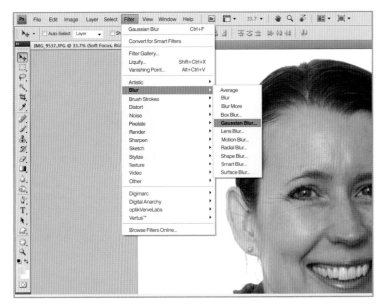

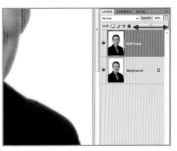

2. To create a soft-focus effect, with the duplicate layer selected in the Layers palette, open the Gaussian Blur dialog box (Filters >> Blur >> Gaussian Blur).

4. At this stage, the level of blur is pronounced. To bring back some of the original image detail while retaining the soft-focus effect, reduce the opacity using the Opacity slider on the Layers palette. A level of between 40 and 60 percent should be sufficient, but use the Preview option to set the exact level.

To fine-tune the image by giving some areas sharper detail (such as the eyes), use a layer mask and the Paintbrush tool.

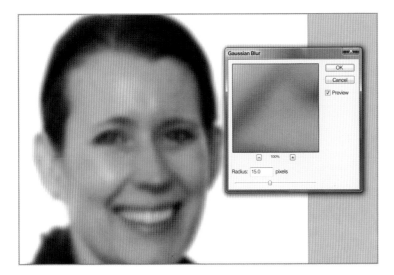

3. Set the level of blur by adjusting the Radius control slider. The higher the number of pixels set, the greater the level of blur. What you are aiming for is a level where the image is softened but not degraded beyond recognition. Check the Preview box and use the preview window to set appropriate level of blur, then click OK.

DIFFERENT DEGREES OF BLUR

Just as there are different strengths of optical soft-focus filter, degrees of softening can be applied digitally by increasing or reducing the amount of Gaussian Blur applied.

One area where digital filters are especially useful is with black-and-white photography. Although some digital cameras have a black-and-white capture mode, there are limits to what can be achieved in-camera, partly because the black-and-white mode relies on postcapture, in-camera processing. There are also quality issues surrounding the in-camera black-and-white mode that makes creating a monotone image in Photoshop from a color original a better option than in-camera capture.

There are many ways to process black-and-white images in Photoshop and different effects that can be applied. What we are going to look at here are some of the most popular techniques for creating realistic but dramatic monotone images, including a few special effects, such as split-toning and a method of replicating the effects of infrared film, which is increasingly difficult to come by.

Creating simple black-and-white images
If you want a quick and simple method of creating black-and-white images in Photoshop, you can use the Black-and-White Adjustment tool in the Image menu.

BEFORE

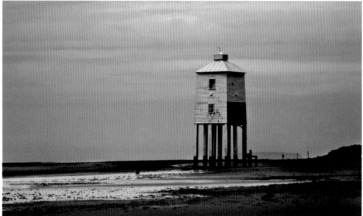

AFTER

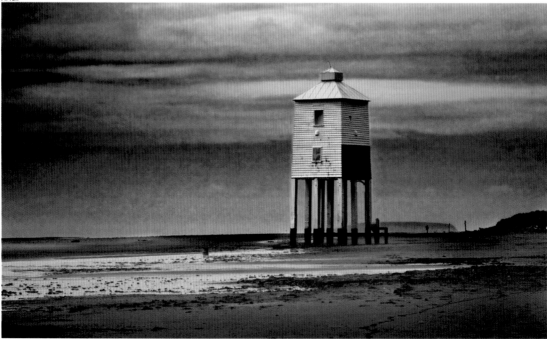

1. With an image open in Photoshop, go to the Black & White dialog box (Image >> Adjustments >> Black & White). Selecting this option will turn the Background layer to black and white.

The default conversion is unlikely to produce a great result and will most probably need fine-tuning.

2. Open the Preset drop-down menu and select different filter types to preview their effect. Select one that creates an effect you are happy with and click OK, or go to step 3.

The Black & White dialog box has a number of preset filters in the drop-down menu. These include some filters associated with black-and-white film photography, such as red, yellow, blue, and green, as well as some other options. These filters create an effect equivalent to their optical counterparts. For example, selecting the red filter preset will lighten red channels, the green filter will lighten green channels, and so on.

3. Below the Preset option there are a number of sliders controlling colors. You can adjust these sliders to produce a custom black-and-white effect. When you have an effect you're happy with, click OK.

The color bars in the Black & White dialog box have a similar effect to using colored filters in black-and-white film photography. If you apply the same rules, that the effect of a filter is to lighten its own colors in the image, then you can visualize the effects of adjusting any of the sliders. Setting an amount greater than zero will lighten the respective color channel, and setting an amount less than zero will darken it.

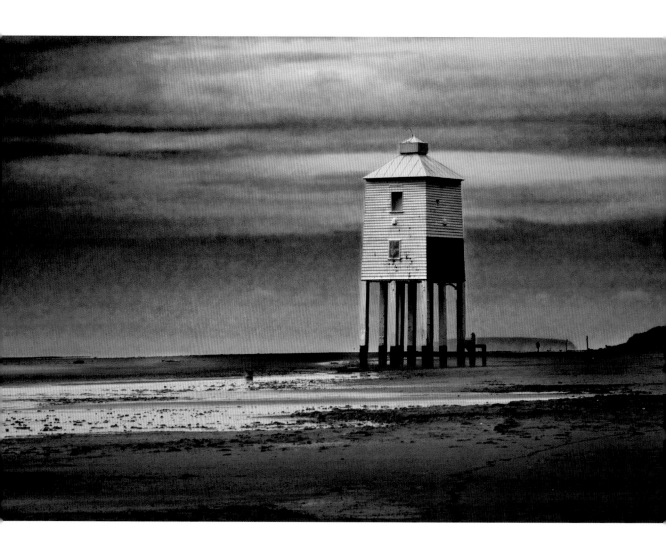

CREATING SIMPLE SEPIA TONE IMAGES

Follow the steps for creating realistic black-and-white images and then apply these additional steps:

4. With the Black & White dialog box open, check the box marked Tint.

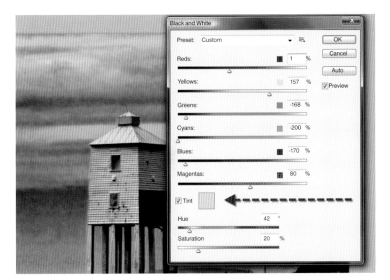

5. Drag the Hue slider across to a point below the color orange.

6. Using the Saturation slider, adjust saturation until you have an effect you're happy with. Dragging the slider to the right will increase the intensity of the sepia effect; dragging it to the left will reduce it.

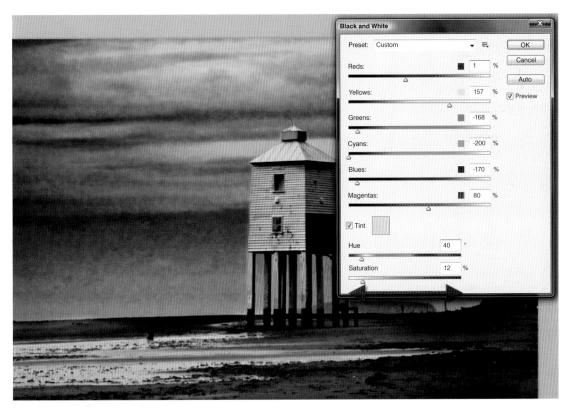

BLACK-AND-WHITE FILTER TECHNIQUES

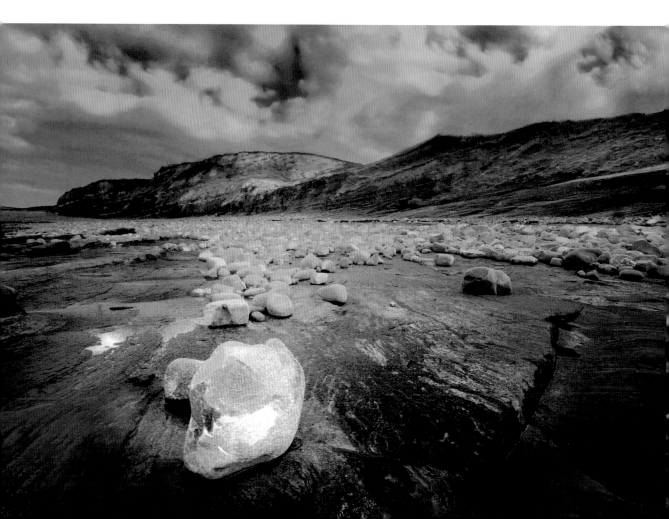

CREATING BLACK-AND-WHITE FILTER TECHNIQUES WITH THE CHANNEL MIXER

The Channel Mixer dialog box provides five preset colored filters that can be applied to a black-and-white image. These filters mimic the effects of the colored filters used in black-and-white film photography and include red, orange, yellow, green, and blue. Selecting any of these presets will produce an effect relative to having captured a black-and-white image on film using an equivalent colored optical filter.

The professionals' choice when it comes to creating black-and-white images in Photoshop is a method that utilizes the Channel Mixer tool.

1. With an image open in Photoshop, create a new Channel Mixer Adjustment layer (Layer >> New Adjustment Layer >> Channel Mixer). Give the layer an appropriate name.

2. In the Channel Mixer dialog box, check the box marked Monochrome (bottom left corner).

This will convert the image to a grayscale image. The image can now be fine-tuned to create a professional finish.

3. Use the Source Channel sliders to adjust the red, green, and blue channel values.

The Source Channel sliders work in a similar way to red, green, and blue optical filters in black-and-white film photography, except with this digital version you have a greater degree of control and can subtract as well as add to each filters' effects.

For example, if you were to use a red optical filter with black-and-white film, the result would be lighter red wavelengths. In the Photoshop Channel Mixer, increasing the red channel value above zero will achieve the equivalent of adding a red filter in film photography (with the red color channels lightened). The higher the value, the lighter the red channels will become.

Additionally, by reducing the value of the red channel to a negative value, you can darken red channels. The green and blue sliders work in exactly the same way, lightening their own color channel when a value above zero is set and darkening it when a negative value is set.

When making adjustments, it is important that the sum of the three channels always adds up to a total of 100 percent, otherwise detail may be lost or contrast reduced. There is a total value underneath the blue channel slider that warns you when the total value is more or less than 100 percent. Once done, click OK.

SPLIT TONING

Split toning is one method of adding extra visual interest to a black-and-white image. The technique involves adding one color tint to the highlights and another to the shadow areas.

BEFORE

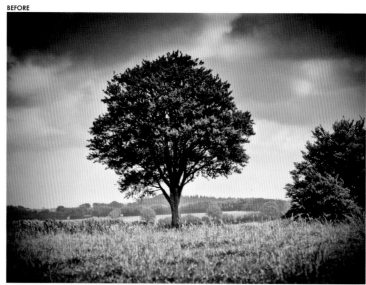

AFTER

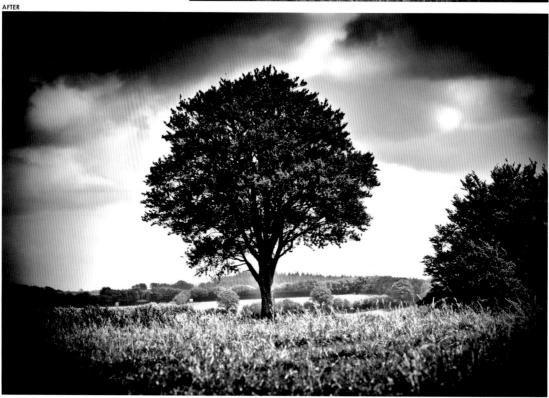

STEP 1

1. With an image open in Photoshop, create a Channel Mixer Adjustment Layer (Layer >> New Adjustment Layer >> Channel Mixer). Give the layer an appropriate name.

2. From the Channel Mixer dialog box, check the box marked Monotone (bottom left corner). The on-screen image will change to a black-and-white image.

STEP 2

We are now going to create a custom black-and-white version of the image using the Red, Green, and Blue sliders in the Channel Mixer dialog box.

3. Use the Source Channel sliders to adjust the image until you have a black-and-white image that you're happy with. Use the guidelines given on page 171 for an understanding of how to set red, green, and blue channel values. Also, remember that when making adjustments, it is important that the sum of the three channels always adds up to a total of 100 percent. Once done, click OK.

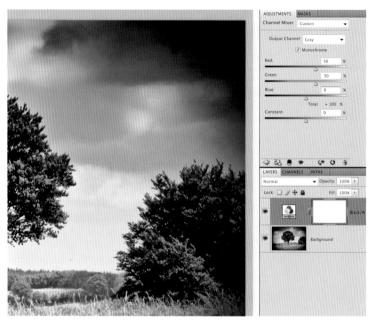

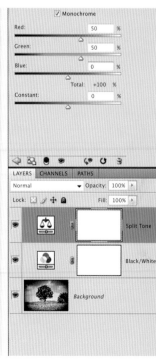

Now that we have a black-and-white image, we are going to begin the split toning procedure.

4. Add a new Color Balance Adjustment Layer (Layer >> New Adjustment Layer >> Color Balance). Give the layer an appropriate name.

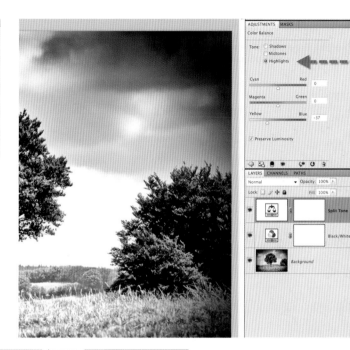

5. The Color Balance dialog box will appear on screen. This gives us the colors we can apply (cyan, red, magenta, green, yellow, and blue) and enables us to select the tones to which selected colors are applied (shadows, midtones, and highlights). First select Highlights by clicking on the appropriate button.

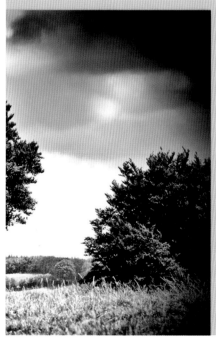

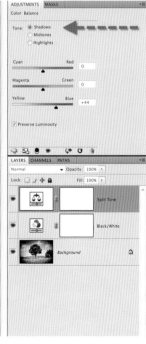

6. To add a color tint, choose which color you want to apply and drag the slider to an appropriate position, using the preview image as a guide.

7. Select Shadows by clicking on the appropriate button. Choose a different tint to apply and drag the slider to an appropriate position, again using Preview Image as a guide.

CREATING A BLACK-AND-WHITE INFRARED IMAGE

With a very limited supply of infrared film available on the market (there is currently only one infrared film being manufactured), digital photography has given infrared enthusiasts a new lease of life. In Section 3 I discussed how it is possible to convert a digital camera to record infrared wavelengths. If you prefer not to permanently convert your prized DSLR but still want to explore infrared photography then here's a way to do it using Photoshop.

BEFORE

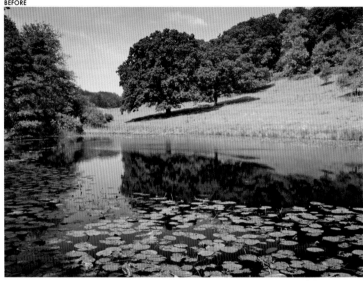

AFTER

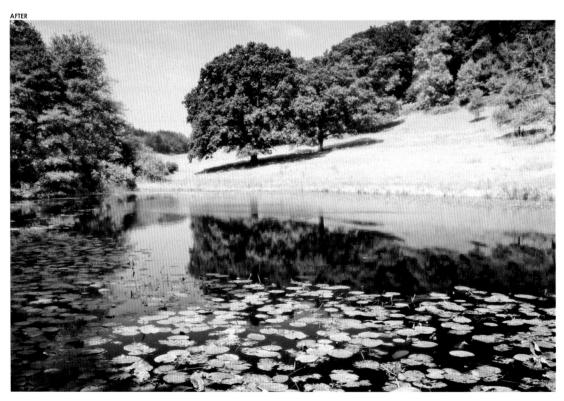

1. With an image open in Photoshop, create a duplicate layer (Layer >> Duplicate Layer). Give the layer an appropriate name.

2. Open the Layers palette and click on the Channels tab. Select the Green channel. This will temporarily convert the image to black and white.

3. Next we are going to apply Gaussian Blur to the green channel. Open the Gaussian Blur dialog box (Filter >> Blur >> Gaussian Blur) and set a Radius value of around 10 pixels (the exact amount will depend on the resolution of the image being worked on—the final effect should show enough detail that the subject can be recognized but not so much that detail appears sharp).

4. In the Layers palette, click on the Layers tab and, with the duplicate layer still selected, from the drop-down menu set Blend Mode to Screen. The image on screen will change, becoming almost white in parts.

5. Add a Channel Mixer Adjustment Layer (Layer >> New Adjustment Layer >> Channel Mixer). Give it an appropriate name.

6. Adjust the Red, Green, and Blue Source Channels by dragging the relevant sliders. When making adjustments, ensure that the sum of all three channels adds up to a total of 100 percent to avoid losing detail or reducing contrast. Alternatively, you could select the Black & White Infrared preset option from the Channel Mixer drop-down menu. When you have an effect you are happy with, check the Monochrome box (bottom left corner) and click OK.

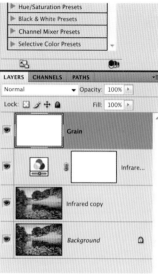

7. To reduce the intensity of the infrared effect, select the duplicate layer created at Step 1 in the Layers palette. Using the Opacity control, reduce opacity to an appropriate level, using Preview Image as a guide.

You now have the equivalent of an infrared image. However, infrared film images are often grainy and you may want to replicate this effect in your digital infrared image. To do so, follow these additional steps:

9. Press the letter D on the keyboard to set the foreground and background colors to the default setting. With the new layer selected, on the keyboard press Ctrl + Backspace (PC) or Command + Delete (Mac) to fill the layer with white. The image will become hidden from view on screen.

To create a grain effect, we're going to add some noise.

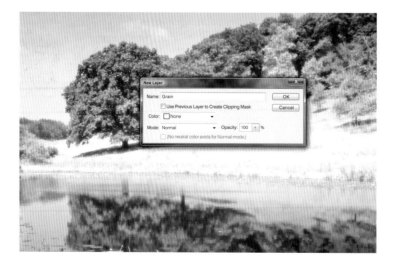

8. Add a new layer above the top layer (Layer >> New >> Layer). Give it an appropriate name.

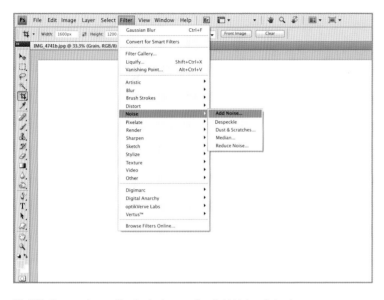

10. With the new layer still selected, open the Add Noise dialog box (Filter >> Noise >> Add Noise).

11. In the Amount box, set a value of 20 percent. For Distribution, select the Uniform setting. Finally, check the box marked Monochromatic. Click OK.

12. In the Layers palette, change the Blend mode for this layer to Multiply. The original image will become visible again. If the level of grain is too high, reduce the layer's opacity using the Opacity control in the Layers palette.

COLOR TONING INFRARED IMAGES
To add a color tint to a black-and-white infrared image, follow the steps for creating a black-and-white infrared image and after Step 12, follow these additional steps:

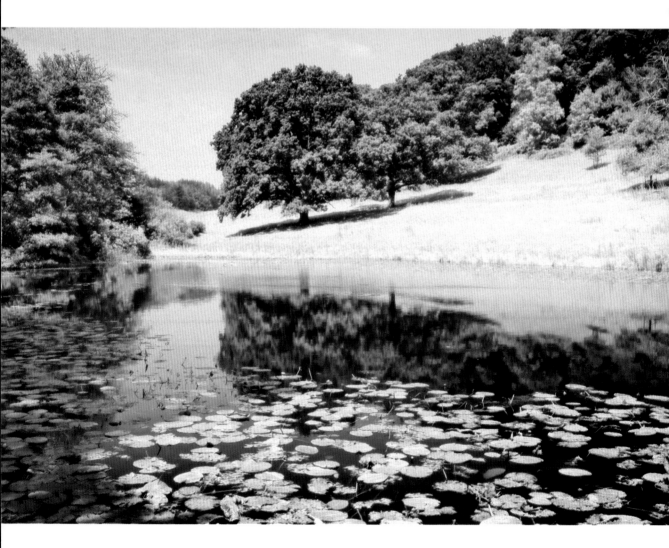

13. In the Layers palette, select the Background layer. Create a new duplicate layer (Layer >> Duplicate Layer). Give it an appropriate name.

14. Drag the new duplicate layer between the Channel Mixer layer and the Noise (Grain) layer.

15. In the Layers palette, set the Blend mode of the new duplicate layer to Overlay and set opacity to a value between 40 and 60 percent.